LINCOLN

TABER

MCMXLI

MCMLXXXIX

'A BIT OF TROMPE'

The Art of Lincoln Taber 1941–89

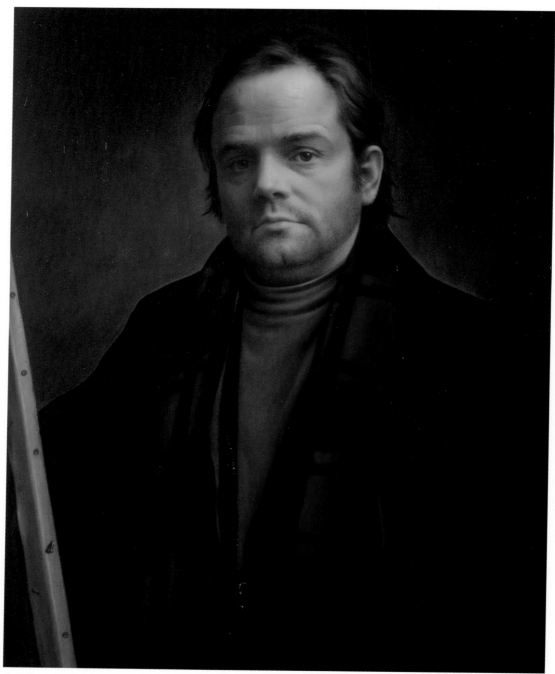

Self Portrait. Oil on board. 30 x 24 in., 1980, collection A. L. Taber III.

'A BIT OF TROMPE'
The Art of Lincoln Taber 1941–89

JULIAN HALSBY AND JACQUELINE TABER

UNICORN PRESS

LONDON

Unicorn Press
21 Afghan Road
London SW11 2QD

Published by Unicorn Press 1998
Text copyright © Julian Halsby and Jaqueline Taber 1998
Illustrations © Jacqueline Taber 1998

ISBN 0-906290-19-8

Designed by Nick Raven
Produced by Pardoe Blacker Limited
Printed in Singapore by HBM Print Ltd

Photography by Paul Conran, Curtis Lane & Co,
Rupert Conant, Gareth Davies, Roy Fox, Peter Hewitt,
James Mortimer, *House and Garden*, Charles Seely,
John Simmons, Mickey Slingsby, Rodney Todd,
White & Son.

ENDPAPERS: From a commemorative window in Fingringhoe Church by Laurence Whistler OBE.

This book is dedicated to the memory of a
most extraordinary man and artist

Without the help and encouragement of David Wolfers and Peter William Fane this book would not have been possible.

Acknowledgements

My grateful thanks to the following who have sponsored this book:

Sir David Brooke
Mr and Mrs William Byrnes
The Lord Camoys
Mrs Jeremy Cohen
Hal Danby Esq.
Oliver Eley Esq.
Peter English Esq.
Peter Fane Esq.
The Worshipful Company of Fishmongers
Mrs William Hall
Philip Hope-Cobbold Esq.

Mrs Robert Keefer
Flavia Ormond
Rathbones plc
Mrs John Rex
Dr John Sanderson
Derek Strauss Esq.
The Lady Juliet Tadgell
Simon Taylor Esq.
Mrs Catherine Whitworth-Jones
Mrs S. Williams
David Wolfers Esq.

A big thank you also to Laurent-Perrier UK plc, Richard Cobbold, of Barwell & Jones, Dudley Winterbottom of the Chelsea Arts Club, Major Charles Fenwick of the Chelsea Gardener, Jonathan Coe, The Friends of the Minories, Nöel Napier-Ford, Marchese Sarah Niccolini, Hugh Tempest-Radford, Julian Halsby, Laurence Whistler OBE, New Grafton Gallery and all the kind friends who have let me reproduce their pictures by Linc.

Jacqueline Taber

CONTENTS

The early years 1941—61 9

Florence 1961—67

 Signorina Simi's Studio 11

 Spain and Salvador Dali 14

 The Agony and the Ecstasy 15

 Student life in Florence 16

 Visits to England in 1965 and 1966 17

 The studio of Pietro Annigoni 18

 The flood and the move to England 19

England 1967—88

 The portraits 22

 The nudes 35

 The murals 38

 The easel paintings 47

The final years 1985—89 67

List of Exhibitions 72

Catalogue Raisonné 73

List of Subscribers 92

THE EARLY YEARS 1941–1961

Lincoln with his father, Lincoln Senior, 1945.

Lincoln Taber was born on 18th August 1941 at the Good Samaritan Hospital, Los Angeles, to Lincoln and Clara Taber. A few years before his birth, Lincoln's father suffered serious head injuries in a car accident which left him an invalid and subject to epileptic seizures. Lincoln's relationship with his mother Clara, who became the predominant force in his childhood, was not always a happy one.

Lincoln's uncle, Erle Halliburton, had invented a system for cementing oil well casings in deep wells. Like many entrepreneurs, he was determined to exploit his invention and even pawned his wedding ring to raise funds. The system worked well and the financial rewards soon became evident as the company he had formed in Duncan, Oklahoma prospered. He invited his brother-in-law to work with him and for a number of years the Tabers lived in Duncan, where two girls were born to them. However following the accident, the Halliburtons bought a ranch in Baldwin Park, West Covina, near Los Angeles to provide a sanctuary for the young Taber family. Lincoln Senior and Clara had 3 children in all, but Vida the eldest child drowned in a swimming pool accident aged 14 months, leaving Lincoln Junior and his elder sister Zola.

With an invalid husband who was often in hospital receiving treatment, Clara was left to manage the family on the chicken ranch which she ran capably. Circumstances forced her to be tough and self-reliant and Lincoln came both to fear and respect her. George Gutierrez, who as a student stayed with the Tabers, wrote of Clara Taber "She was in charge of the family and was used to making all the decisions that needed to be made and had a tendency to try to run everyone else's lives."

The children were brought up to cope with their father's disabilities, although he remained a charming and delightful companion. George Gutierrez recalls "Lincoln Sr was a very sweet and quiet person. He would wander around the premises, cutting flowers, doing some gardening, and taking fruits from the trees; or sometimes he would disappear into one of the rooms in the garden to listen to an old radio... Mr Taber would usually go to bed right after dinner, and I never saw him participate in any family activities." The financial problems of the Taber family were eased by the generosity of the Halliburtons who kept a watchful eye over their relations, setting up a trust fund to benefit the children.

George Gutierrez remembers Lincoln Junior as "a very quiet person who had a unique personality with an extraordinary sense of humour. He was three years younger than I, and in his quiet way, he became very close to me. He enjoyed hanging around my room while I was studying and would try not to disturb me. He would quietly read a hot rod magazine, and dreamed about building one. He would sometimes work on a drawing..."

Lincoln Junior was educated at Baldwin High Park School where he showed a precocious talent for drawing strange and surrealist objects. Following school Lincoln went to Mount San Antonio College. He was often unhappy at home and on several occasions ran away. He was also at times in trouble with the police for speeding, hot rods being an abiding passion, and occasionally for under age drinking. However his mother always managed to deal diplomatically with the police and no serious consequences followed.

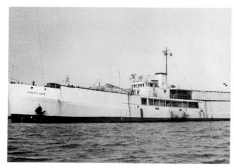

Magu's Luck, 1959.

It was assumed by the family that Lincoln would join the Halliburton oil business, but he was determined to become an artist. While at college, he had designed a number of posters for various events, such as college elections, auctions and dances. He also drew both from observation and from his imagination, and an early sketchbook contains studies from life.

In 1959 his father died, and Lincoln decided that the time had come to broaden his horizons. The opportunity came when a family friend, Captain Roy Deskin, invited him and George Gutierrez to join the ship *Magu's Luck* which he was delivering to the Persian Gulf. *Magu's Luck* was a former minesweeper which was being converted into a shrimp fishing and processing vessel. Lincoln worked in the engine room, but the ship was old and not in good shape and, after a difficult crossing during which they had lost power completely during a storm, they put into Malta for repairs. While *Magu's Luck* was in Malta, Lincoln and his friend visited Rome by train, then bought Lambrettas on which they continued up to the French Riviera, Barcelona and Madrid where George remained to start his medical studies.

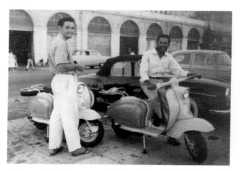

George Gutierrez and Lincoln with their Lambrettas, Nice, 1959.

Lincoln returned alone to the *Magu's Luck* which then sailed for the Persian Gulf passing through the Suez Canal. Here Lincoln had some time to visit the pyramids outside Cairo. Finally leaving the ship in the Persian Gulf, he visited Teheran before returning to the United States. Unfortunately he forgot to have his passport stamped on arrival in Persia, and was held in house arrest for two months, accused of being a spy, before the American Consulate could finally get permission for him to return home. He returned to the United States via Vietnam, where the family had friends, and Hawaii.

For some months, Lincoln returned to his studies at San Antonio College, but he felt increasingly frustrated with academic work, believing that his real talent lay in art. His mother, who was concerned about his future, discussed the situation with Erle and David Halliburton, and it was agreed to send Lincoln to Paris to study art.

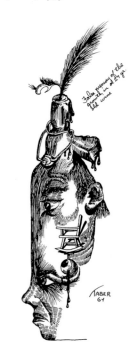

Lincoln had heard much about Paris as the centre of art and was keen to join what he perceived to be a lively artistic society. He soon became disillusioned. Alone and friendless, he found Paris did not live up to his expectations and was much more expensive than he had imagined. However, a new possibility was on the horizon. In a letter to his mother from the Hotel Richardet, Paris, dated 21st July 1961, he wrote:

I met an Italian student today who is a student in Florence, Italy, which is another art capital famous for their schools of art. He is going back the first

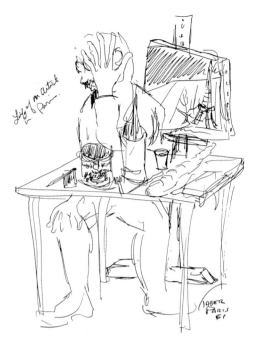

of August and is going to check the prices of everything for me and write me a letter. I may decide to go to school there because I can live for half the price of what I am paying here. There are no pensions left in Paris where you can get room and board. I am staying now in a dumpy hotel on the left bank for a little more than $2 a day with no bath. The meals are terribly expensive even in the smallest cafe in the worst part of town. When people would tell me it cost more to live in Paris than the US, I thought they were probably just in the wrong section, but it is expensive even on the left bank. On the other side there are no hotels less than 8 or 10 dollars a night... Personally at the moment I feel we would be better off with me in a school in Italy where I can live for about 3 dollars a day... Don't worry, I'll be sure and be in a school for this semester, the last thing I want to do is loaf around and spend money and not be in school... I will write more later when I find out more about the schools. I have about $260 left, which I hope will last me for a while. I hope you get everything straightened out with the trust and can join me soon.

Lincoln proceeded to enrol at the Beaux Arts but it was his first encounter with academic art teaching and he found the teaching methods stifling. He decided to move on.

FLORENCE 1961–1967

Signorina Simi's studio

In October 1961 Lincoln arrived in Florence with the intention of studying at the Accademia delle Belle Arte, but he found the lack of individual tuition disappointing. There was, however, an alternative to the Accademia which he discovered in the spring of 1962 as a result of making friends with Niccolo Caracciolo.

Niccolo Caracciolo, Piazza S. Spirito, 1962.

The son of an Italian prince who lived in Ireland and had married a Fitzgerald, Niccolo split his time between Ireland and Italy, although despite his parentage and name, his spoken Italian was not good. He was a talented art student who was studying at the Simi School in the Via Tripoli, and encouraged Lincoln to join him.

Signorina Nerina Simi (1890–1987) was the daughter of the Florentine painter, Filadelfo Simi, who had studied in Paris under Jerome. She was herself a good painter, but is remembered above all for her art teaching. Her studio, which had been her father's and was hung with his huge narrative works in heavy gilt frames, was situated beyond the church of Santa Croce. There were two studios, a large one heated by an old fashioned, pot-bellied stove where the life drawing would

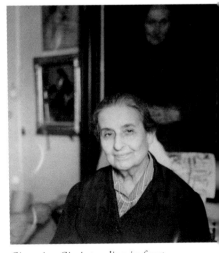

Signorina Simi standing in front of one of her own portraits, 1965.

take place and a smaller room where the beginners would draw from plaster casts. There was also a reception room. The large studio could hold up to 20 students and their easels and could at times become crowded. The morning session from 9 to midday was taken up with drawing nude models, both male and female, while the afternoon session from 2 to 4 was devoted to portraiture.

Beginners were expected to remain for two to three months in the small studio before graduating to the life model room: however students who had successfully mastered drawing, were permitted to return to the small studio to work on still lifes in oils. There was no time scale and students could remain for years drawing before being allowed to touch colour. The Signorina was aware of the financial hardships of many of her students, and charged high fees from the regular stream of wealthy young girls from finishing schools who were usually confined to the plaster cast room, thereby allowing her more serious students to pay modest termly fees.

Students were expected to conform to certain basic rules which Simi considered essential. Drawing was executed with willow charcoal sticks which were sharpened to a needle point using razor blades, while putty rubbers or bread were used for taking off. The process of laying the charcoal on and taking off enabled the students to achieve a rounded, three dimensional effect in their drawing which looked similar to Ingres's technique. Rubbing or smudging to achieve rapid effects was not allowed, and there was endless discussion as to which paper and which hardness of charcoal achieved the best results. While Ingres canson paper was

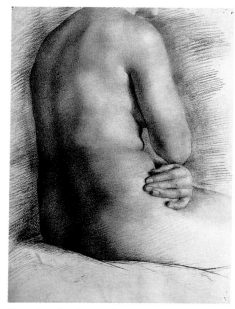

Seated nude, charcoal, 20 x 14 in., 1964, collection Mrs D. Wolfers.

Signorina Simi teaching, 1965.

Lincoln working on a self portrait at Studio Simi, 1965.

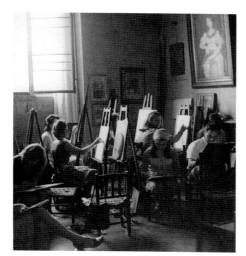

Simi's studio, 1965.

Pietro Annigoni at an exhibition, Florence, 1965.

mostly used, some students would turn up with antique paper purchased in junk shops or taken from old ledgers. Students were expected to work for weeks on a drawing. There were no rapid changes of pose, such as the 5 minute pose so popular in many art schools. Instead poses were held for many sessions and students were expected to develop their drawings to a Renaissance level of finish.

Oil painting was also taught to those few who had, in her view, mastered drawing, and many had to wait up to seven years before being allowed to paint. Even in oils her technique was rigorous. No medium was allowed, neither turps nor oil, and she insisted on a dry brush. At the end of a session, students were expected to wash their brushes in soap and water. They were required to paint a still life set up in the small studio, but she would also encourage students to take their paints into the Tuscan countryside and she would happily criticise the resulting landscapes.

There is no doubt that Signorina Simi was a hard task master. She attended every session, taking great care with each pupil, but her caustic comments were feared. "I think you need glasses" she would often sigh, but she also praised, her highest accolade being "Non c'è male" or "Not too bad." She was a strong personality and in some instances her methods destroyed the intuitive flare of more reticent pupils. On the other hand, her methods provided a sound grounding in drawing, composition and painting which benefited generations of her students.

Pietro Annigoni wrote of Signorina Simi:

For two-thirds of a century she had received students from all over Europe, America and Italy in her Via Tripoli studio. Her reputation as a gifted teacher reached distant countries indirectly through letters and conversations. There was never any official publicity. Yet, the young and not-so-young responded. For Nerina Simi teaching was a mission, so much so that most of us thought she had dedicated her life only to that. Her paintings reveal the source of her exceptional teaching ability, they show her to be one of the most important Italian painters of this century.

Many former pupils, such as Mila Martini Bernardi, have paid tribute to her role in their development of artists:

Immature and inexperienced as I was, I, nevertheless, knew that I had found my way in the person of Nerina Simi. Her competence, dedication and comprehension helped launch her pupils on that marvellous, yet arduous and evasive road to excellence...
I know that those of us who had the good fortune to have been her pupils will never forget her teaching. She is gone. But her vivid, intelligent eyes are still on us and our canvases. On our road and in our search, she remains near.

It was into this school that Lincoln Taber entered in the spring of 1962, soon making his mark as one of Simi's star pupils. In a letter of March 1963 Lincoln wrote:

She has picked me as the one that she wants to work with over the others that are there and always sets me in the best seat and poses the model in the position that she thinks will do me the most good. You will not believe my

progress... I did one exceptional nude study, bigger than life, that she and also Annigoni thought to be exquisite.

On one occasion Lincoln and Niccolo came across an old man on their way home from Simi's:

He had such an interesting face, almost like a Leonardo cartoon, so we asked if he would like to come and sit for us at Simi's studio and of course he accepted as he lives in the home for the aged and has nothing to do all day... He showed up but he was drunk and we didn't realize it until we got him upstairs and he began talking with Simi... Everyone is still laughing about our new model.

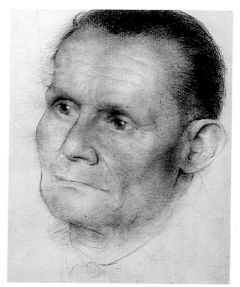

Portrait of an old man, 1964.

Spain and Salvador Dali

While in Florence Lincoln returned regularly to Spain. In June 1962 he visited George Gutierrez in Pamplona accompanied by his mother. They travelled extensively in Northern Spain visiting San Sebastian, Bilbao and the mountains around Pamplona. Clara was planning to buy a Mercedes and ship it back to the States, so they travelled together to Germany, before Lincoln returned to Florence.

In the following year, Lincoln returned to Spain staying with George in Pamplona for about a month before moving on. He greatly admired the work of Salvador Dali, and in fact had tried without success to find Dali's house when in Spain in 1959. He decided to go to the village of Cadaques in Northern Spain where Dali lived. It was difficult to gain access to Dali's house, but Lincoln was fortunate to meet Dali's doctor in the village and he arranged an introduction. He wrote to his mother on 25th August 1963:

I have just come from Dali's house after meeting and talking with him... He was very busy, but took time to talk to me and explain all about his new painting (which in my estimation is phenomenal and when finished will surely be his best)... I wouldn't have traded this visit to visit anyone else in the world. He is certainly everything and more than expected.

In some notes written many years later, Lincoln recalled meeting Dali's wife Gala:

When Gala was there it was almost impossible to see him. Gala often clambered on the tiled rooftops of the house during the day doing I don't know what. The house in Port Iligat was a mystery in itself, having been added onto over several decades until it became a maze of small rooms running up the hill...

Lincoln asked if he could return with his drawings for Dali's criticism, to which he agreed. On October 5th 1963 Lincoln wrote to his mother that Dali had looked at the drawings, considered them good, but had added that he should "start being original and bringing your personality into the work."

He showed me countless photographs and paintings and geometrical forms and explained everything in detail: a lot of what he said is just beginning to come to me. I am going to write everything down this evening. The people tell me my portfolio that has been handled by Dali is worth a lot now, but

Lincoln with his mother Clara, 1964.

I assure you that is not at all the reason I took it to him, and I'm sure he realises that… I told him I would be back in the future when I am more advanced and have something that will interest him. He said Annigoni has little originality; I agreed as it is true.

Lincoln left Cadaques around 8th October. He wrote "I have accomplished what I wanted and as much or more than I expected", but he was keen to return to Florence and the discipline of Signorina Simi's studio.

The Agony and the Ecstasy

Shortly after returning to Florence, Lincoln moved into a villa owned by Signora Maria Comberti which was situated near the Forte di Belevedere. Signora Comberti, a Quaker, was a formidable character who took in paying guests whom she ruled with a rod of iron. She had been married to a German and her villa was full of original Bauhaus furniture. Although no beauty, she was venerated by her guests and understood their inevitable financial problems. She took a liking to Lincoln and would write letters to his mother telling her how hard he was working. The relationship lasted for many years, and long after Lincoln had left Florence, he would return to visit his first landlady.

Signora Comberti.

In 1964 he was invited to work on the film set of "The Agony and the Ecstasy" which was being made at Cina Città in Rome. The film featured the story of Michelangelo (played by Charlton Heston) and his relationship with the Pope (Rex Harrison) during the period he spent painting the Sistine Chapel in Rome. The task was to paint a life-size copy of the Sistine Chapel ceiling as well as other panels which were then systematically destroyed by Charlton Heston in the film. The first task in mid-July was to produce a copy of Michelangelo's painting of St Peter which he did with Christian Lindberg Sterum, a Belgian student from Signorina Simi's, Fernando Bernadini and Niccolo Caracciolo.

Later that month he began work on the reconstruction of the ceiling. In a letter from Rome dated May 22nd 1964 Lincoln told his mother about the project:

> I met today the man who is in charge of the sets and who won an "Oscar" for his direction of the scenario in "Cleopatra". He took me all around Cina Città and introduced me to everyone… I will be paid 100 dollars a week for my work plus 15 dollars a day for expenses.
> We are treated with the same respect as the actors as the scenes of the Sistine chapel are the most important part of the film. When I signed on today it was as "technician artist"…
> We are all painting on panels of plastic with tempera all of the frescoes in the Sistine Chapel by means of projection.

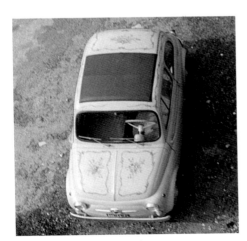

The painted Fiat 500, 1965.

For the ceiling project, Lincoln was the only foreigner amongst the 15 Roman scene painters, and it appears that the commission had come through a Florentine painter, Verdianelli, whose studio he had rented for some months in 1963. The work was well paid and as a result of his three months work, Lincoln was able to buy himself a Fiat 500 which he decorated with flowers to look like a piece of

Venetian furniture. The car caused quite a sensation in Florence, and when it was destroyed in the flood of 1966, Lincoln was easily able to identify it, for insurance purposes, amongst the thousands of wrecked cars stored at the Cascine.

Student life in Florence

Shortly after his Roman interlude, Lincoln was called up for military service which would certainly have involved active service in Vietnam. He managed to avoid being drafted because of cracked heels sustained while high jumping at school. He attended a medical at Livorno, but the condition of his feet, combined with the fact that he had been in trouble with the police while at school and was technically a felon, resulted in his being graded 4F. This meant that he would only be called upon to serve in a real emergency, and it was with great relief that he returned to Florence. In the autumn of that year, Lincoln met a young English girl, Jacqueline Birch, who had joined Signorina Simi's school. Jacqueline was later to become his wife.

Lincoln in Florence, pictured with Jacqueline Birch and Tristram Barran.

Richard Foster, now a successful portrait and landscape painter, arrived in Florence in the autumn of 1963 and enrolled at Signorina Simi's studio. Here he met Lincoln and was to remain a friend until Lincoln's death in 1989. He has described the young man he met in 1963:

> Lincoln was a very friendly, charming and kind person and it was impossible not to like him. He was quite tall with dark reddy brown hair and a round face. I would describe him as physically attractive. He was very gentle and in a discussion would always see the other point of view: he was also extremely generous.
>
> I felt that he was possibly too gentle for his own good and that he lacked a strategic plan for his life. He maybe wasn't ruthless enough, and yet this was part of his charm.
>
> He never talked about his childhood nor his family in California, and I always felt a slight sadness in his heart. Yet he was great company and when he and his inseparable friend Niccolo Caracciolo went out for an evening, they would go round all the bars in Florence pretending to be drunk, their elbows slipping off the zinc counters. Lincoln's nickname was "Il Finimondo", literally the "end of the world", but meaning a disaster.

Another contemporary has described Lincoln as he was in Florence:

> He was nearly 6ft tall with a large leonine head and big, beautiful hands. He always had a great sense of humour and a lovely smile which reinforced his enormous charm. He was softly spoken with a very slight American accent, and was always quiet and unassuming. He wore his hair long and often had a pearl necklace.
>
> He loved the Italian Renaissance masters such as Andrea dell Sarto, Raphael and Leonardo, but had no time at all for most modern art.

Student life in Florence was fun, although Lincoln was often short of money and lived a hand-to-mouth existence. Like many students, he would often exchange a painting for meals or for art materials. A more substantial commission arose in 1964

Copy of del Sarto by Lincoln, 1964.

Painting the mural at Trattoria Oreste.

when he was asked to paint a mural for the Trattoria Oreste in Piazza Santo Spirito. The mural was to run the full length of the main restaurant area and the fee was to be free meals for four years. However when Lincoln asked that his girlfriend Jacqueline be included, the period was reduced to two years! The mural depicted a panorama of the Florentine roof tops, and using a visual joke that he was to repeat in various guises in later years, Lincoln included a mouse, which had been caught in the restaurant, peeping out of a crack in the wall. Unfortunately the owner of the trattoria made Lincoln paint it out as he felt it was not a good testimony to the hygiene of his establishment.

In July 1965 Lincoln took part in an exhibition of classical painting in Piazza Santo Spirito showing works from former students of Signorina Simi and Pietro Annigoni. He exhibited a portrait of himself as well as a painting of burning giraffes rather in the style of Salvator Dali.

> We will present about 30 artists, all of course realists, and many who have become prominent artists but that have studied with Annigoni or Simi in the past. I am already certain that my paintings will be among the most discussed (modestamente)...

Visits to England 1965 and 1966

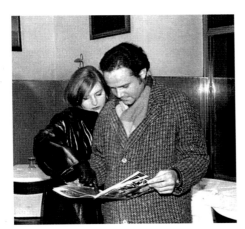

Lincoln and Jacqueline, 1965.

In July 1965 he made his first visit to England to stay with Jacqueline Birch's family at their cottage, "Jaggers", in the village of Fingringhoe near Colchester in Essex. Simon Birch had trained as an architect but, finding it difficult to make a living, had become a stockbroker. Nevertheless he continued to paint as a hobby and had a great interest in the arts. His wife, Bettine, had studied art at Chelsea and was also a painter, so they found Lincoln a fascinating guest. "Jaggers" was a small farmhouse with outbuildings, and Lincoln was invited to paint a mural in the barn depicting Jacqueline sitting on a wall against a Suffolk landscape.

While in Fingringhoe, he paid a visit to Randolph Churchill who lived nearby in East Bergholt. Lincoln recorded this visit in a letter to his mother:

> We went to visit Randolph Churchill, the only son of Winston, to whom he was very devoted. He is now writing a book on his father's life which is almost completed... He is having his daughter painted by Annigoni. We talked for hours about painting (He knows very little and asked my advice on many things). Annigoni is asking 8000 dollars for a head and shoulders portrait...
> He also has all of Winston's paintings. They were not bad considering he was only a Sunday painter, but there was very little quality in them.
> They have just sold one of Winston's paintings for 42,000 dollars, and he told me they expect them to increase in value for the next five years...
> Classical painting is so much admired here, and I believe here and in America is where the money is to be made, at least that is where Annigoni has made his fortune and fame. When I return I will probably work in the morning with him and in the evening with Simi. I hope she will not mind and perhaps I shouldn't tell her, but it is very necessary that I get under someone that has a name.

In the summer of 1966 Lincoln again drove to England from Florence meeting potential clients for murals. He noted the difference between what young girls in Florence and London wore:

> You should see the girls in London. They are wearing dresses (they call them mini-skirts) that are 9 or 10 inches above the knee. I think they are very nice if the girls have the right legs.

Once again he stayed with Jacqueline Birch's parents, and in a letter to his mother dated July 22nd 1966 he wrote for the first time about his girl friend:

> Jacqueline is studying restoring at the Uffizi Galleries and painting at Simi's. We often go out together to paint on Sundays when we are in Florence. She is 20 years old and very well educated at the best private schools in England and was in a girls finishing school in France for a year. She has such a great respect for me and for what reason I'll never know. I am so mean to her… She is always thinking of me and buying me clothes and gifts and I do nothing for her.

The studio of Pietro Annigoni

One of the ambitions of many of Signorina Simi's pupils was ultimately to work with Pietro Annigoni, the acknowledged maestro whose 1953 portrait of Queen Elizabeth had caused a sensation. Lincoln hoped ultimately to progress to Annigoni's studio:

> I hope to study with him next year, not for the fact that he is better than the Signorina, but because of his reputation. He himself says no person can compare with Simi in teaching painting.

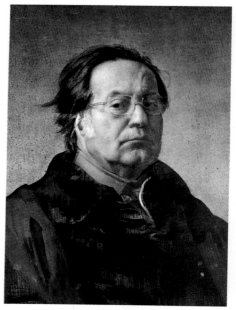

PIETRO ANNIGONI: *Self Portrait.*

Annigoni painted large frescoes in addition to portraits and always needed assistants, although he only took the most talented of Simi's students. There was no formal interview or examination and Lincoln went round to Annigoni's studio on several occasions with his drawings. He would ask "Maestro can I be your pupil?" He was delighted when, in the autumn of 1964, Annigoni agreed, although he was not paid except for living expenses and food. It was, in effect, an apprenticeship. Annigoni's studio was like a Renaissance court with camp followers and courtiers who gathered around their prince either in the studio in the Borgo degli Albizi near the Duomo or at Angelino's Trattoria.

While Lincoln continued to attend Simi's studio, he was spending more time with Annigoni. In a letter of 27th February 1966 he wrote:

> I have been working so hard these last few days doing studies from Annigoni's studio window looking out over the roof tops of old Florence. He is becoming very interested in my work and is giving me so much help. He came with me to lunch at the trattoria in S Spirito (a great honor for the proprietor) …expressly to see my mural and give me advice. He was very pleased with what I had done and of course had several ideas on how to make it better. For this reason he is having me do these sketches from his

Drawing from Annigoni's studio, 1964.

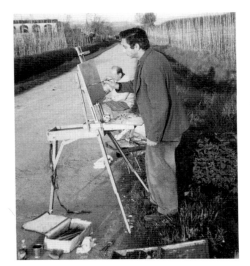

Fernando Bernardini painting Ponte Bugginese.

Pricking out the cartoons for the frescoes by Pietro Annigoni at Ponte Bugginese. Nando Bernadini, Lincoln and an assistant.

Landscape painting at Ponte Bugginese.

window. I am also doing a drawing of a plaster cast... He came up the other morning and found almost everything that I had done wrong and showed me how to correct it. I am working on a still life in oil at Simi's in the afternoon, and I began a landscape in the country last Sunday.

One of the first of Annigoni's assistants that Lincoln met was Fernando Bernardini, known as Nando, who ground and mixed Annigoni's colours. Other assistants who became friends were Stefanelli, Pistolese and Guanieri. One project on which Lincoln was involved was a huge fresco for a church at Ponte Bugginese, in a rather bleak area of Tuscany. The work was funded by Italians working abroad, and Annigoni executed the frescoes in a technique that went back to the Renaissance. Huge cartoons were drawn then pricked with pins before being transferred to freshly applied plaster by "poncing" the outlines using chalk dust. The area of wall plastered each day was just enough to be finished by the evening, and the following day a new area was prepared. After the day's work, the assistants would eat, drink chianti and often, while someone played the organ, Guanieri would sing. Annigoni could not drive and had no car, so Lincoln and his multi-coloured Fiat Cinquecento were in demand.

Lincoln was also continuing with his own work, painting still lifes and nudes. He had moved to a flat in the Via Magliabechi near Santa Croce. Money was always a problem despite an allowance from the United States, and he was obliged to do a number of art related jobs to make ends meet. One such job was designing two packets for camomile tea, sold by a herbalist called Dottore Comis who operated out of a one-room factory in Piazza Santo Spirito. Lincoln produced two designs, one depicting a field of camomile, the other a blue and white storage pot. He also designed a flag for a local football club and decorations for a bar in the Piazza Santo Spirito. Weekends were usually spent with Jacqueline, often painting in the beautiful countryside around Florence, or spending time with friends eating and drinking. Jacqueline was working mornings at the Uffizi as assistant to Professor Van Merhen, who pioneered X-ray photography of old masters, while continuing to attend Signorina Simi's in the afternoons. She later worked in the gilding department at the Uffizi.

Lincoln was also involved in another mural in late 1965. This was for the Trattoria Quattro Leoni in the Piazza della Passara and depicted a self-portrait of Lincoln in silhouette overlooking Florence with a fiasco of Chianti by his side. Again the commission was paid for in free meals.

The flood and the move to England

This period was in many ways idyllic, although Lincoln realised that with so many artists, it would be virtually impossible to earn a proper living in Florence. He had seen that most of Annigoni's income came from commissions from England and the United States and by the summer of 1966 Lincoln was beginning to discuss seriously the possibility of moving to England.

On 6th November 1966 catastrophe struck without warning when the Arno broke its banks and Florence was flooded. The destruction was enormous: houses,

shops, cars as well as works of art including church frescoes, paintings, ancient documents and books. An immediate international appeal for help was launched and thanks to prompt action many works of art were saved. But life was disrupted for many months as water, electricity and gas supplies were all cut off. Lincoln's car, along with thousands of others, was swept away by the torrent and later sold for scrap. At the time Lincoln was living in a flat in the Via della Vigna Nuova, off the Via Tournabouni, and it was here that he actually saw his car floating past the door of the building. He tried to tie it to a shop grill, but without success. Floating past the same door, he also saw lobsters from a nearby restaurant and expensive Gucci sweaters.

The horror of the event is recorded in his letters:

> Everything is ruined: thousands and thousands of shops, thousands of cars (mine included which hasn't been found yet), the doors of the Baptistery, one whole side of the Ponte Vecchio, all that was stored in the Uffizi Galleries below. They say there was more damage done than was done during the entire second world war... There is no electric power and there will be no water for another fifteen days. Food and water is being brought in by the army and even now all the old part of Florence is still a foot deep in mud. (November 9th)

> A week has passed since the flood and things seem to get worse instead of better as they begin to discover the real extent of the damage done... 20,000 cars were damaged and thousands of those a total write-off; the number of dead is still uncertain as they are still uncovering them and many are lost, all of the best race horses in Italy that were at the Cascine because it was the season are drowned and also all of the animals in the zoo; it will take an estimated 15 years to restore the paintings damaged in the Uffizi...
> There is a horrible stench of rotten meat everywhere...
> I found my car only yesterday demolished in Porta Prato about 2 miles from where it was parked...
> Poor Signorina Simi has gone to the country to stay until things are a little better. Hers being so close to the river was one of the worst hit.
> (November 11th)

As there was very little food in Florence, Lincoln was invited to eat with Jacqueline's landlady, Signora Majoli, who lived just outside the ravaged area of Florence near the Fortezza di Basso. She had friends in Montecatini who sent down water and food. Signora Majoli very much liked Lincoln, whom she called "Bumbaloccia", and enjoyed his company.

After a long period of readjustment, Florence began to return to normal early in 1967. Lincoln was still working with Annigoni but was seriously contemplating settling in England. In July 1967 he wrote to his mother:

> I want to leave for England at the end of this month and though there are many possibilities that are almost secure, there is nothing definite... Anyway I am going with very definite, positive intentions ...and with the portraits I am taking with me as samples, it will be unlikely that I shall not have several

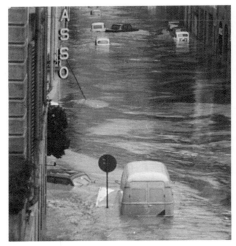

Flood water in the Via della Vigna Nuovo, Florence, 1966.

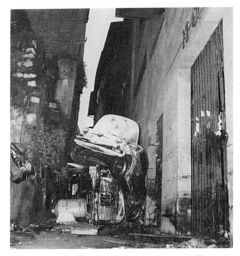

Cars after the flood, Borgo S. Jacapo, Florence.

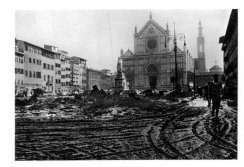

Piazza S. Croce after the flood.

commissions. Annigoni has been such a great help and I am learning so much of his techniques... Last Sunday I went with him on his yacht and I think he was very impressed with the way I handled his boat. After all, I do have some experience and I love the sea.

In fact Lincoln was looking forward with confidence to making a career as a portrait painter and muralist in England and the United States. In the same letter he writes:

I'll bet now there is nobody in the States that can paint a mural that fools the eye and at the same time is full of atmosphere and can be considered a painting, as I can...

In August 1967 Jacqueline and Lincoln loaded a new Fiat Cinquecento with all their belongings, using a roof rack so that more canvases could be kept inside the car, and set off for the long drive back to England. They were to return regularly to Florence over the next 10 years, but were never to live there again.

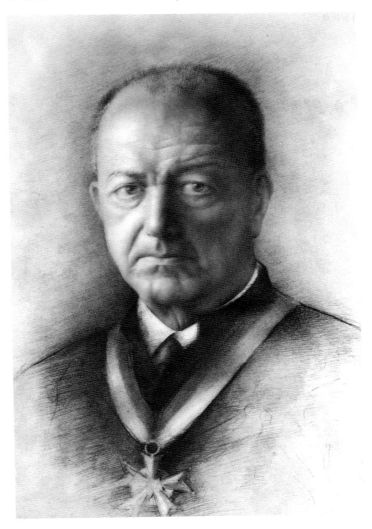

Guilio Benvenuti,
Florence 1966

ENGLAND 1967–1988

The portraits

Lincoln quickly settled down to life in England, staying with the Birch family at Fingringhoe, and through them getting his first major portrait commission, the portrait of Barbara Gerard (opposite). This unusual commission was for a full-length standing nude which Lincoln painted in tempera on board. Work began shortly after arriving in England and continued for two months, the sittings taking place in Barbara Gerard's flat in Sloane Street. One of the problems was that the builders then renovating Harvey Nichols store opposite the flat could see, from the scaffolding, both painter and model and this caused considerable excitement. Lincoln worked on marine plywood which, provided a solid support which would not warp. This was coated in several layers of gesso using the traditional method of whiting and rabbit size. A final coat of a reddish brown oil colour was then applied. Boards for Lincoln's tempera were usually prepared by Jacqueline. The commission was a success and Lincoln received the sum of £600 which was by far the largest amount he had yet earned for a painting and, on the basis of this commission, he and Jacqueline were married.

Lincoln in his studio.

In a letter to his mother of October 3rd 1967, Lincoln wrote:

> We have finally decided to get married in the spring, or rather I finally found the proper moment to ask her father. He was delighted and said he could think of nobody he would rather have as a son-in-law. They are going to give us the house in Fingringhoe which is a fantastic place with a large studio apart from the house where I will do most of my work... I have been terrified of asking him to marry Jacqueline and I knew it was my responsibility and not his to bring it up... Luckily he brought the subject up as we were talking about my future as a painter. He said "and what about Jacqueline?" So we had a long talk and decided there and then that it should be in the spring. I couldn't go through an enormous wedding as he would have preferred it and we agreed that it will be a very quiet one in a registry office in London.

The marriage took place at St Pancras Registry Office on January 15th 1968 with a reception afterwards at Searcy's. The following day, the couple set off in their car for Florence where they stayed a month, revisiting old friends and, after fond farewells, they returned to England with the rest of their belongings including Michael the Mynah bird which Lincoln had requested as a present. Jacqueline's parents had by now moved to Brantham Glebe in Manningtree and they rented "Jaggers" in Fingringhoe to the Tabers. This was to become Lincoln's home and studio for many years until he felt the need to have a London base.

Later that year, Lincoln was commissioned to paint Isabelle Hohler, the daughter of Jacqueline's godmother. The family lived in Hampshire and Lincoln and Jacqueline stayed at the Hohler's house for 6 weeks during the summer while the portrait was painted. The weather was fine and they swam in the pool and ate well. Progress on the portrait was comparatively slow and there was a problem

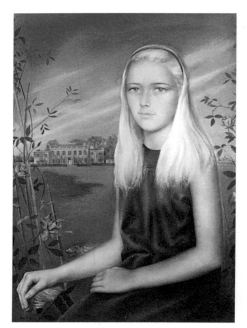
Portrait of Isabelle Hohler before the arm was covered, 1968.

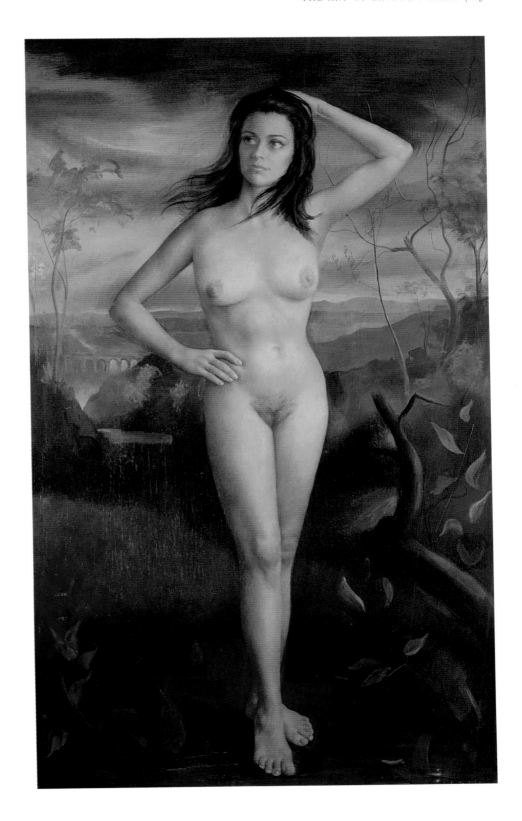

Barbara Gerard. Tempera on panel.
60 x 36 in., 1967, collection
A. L. Taber III.

with the sitter's arm, appearing too solid and dominant in the painting. This was solved by painting a shawl over it. In later portraits Lincoln would sometimes become depressed if the sitter were not happy with it, as in the case of the portrait of James Guinness. The Hohler portrait was executed in oils, because Lincoln hoped that he would be able to work faster in oils than in tempera. However, he was always a slow painter, making careful sketches of his sitter in sanguine which he transferred to board or canvas using tracing paper. He would then require 8–10 sittings of 2 hours each.

Lincoln's parents-in-law were well known in East Anglia and had many connections, and it was through them that he gained many of the earlier portrait commissions. In 1967, shortly after completing the Gerrard portrait, Lincoln painted two tempera portraits of the Curtis children, Emma and Philip. Because of the time required to paint a portrait in oil or tempera, Lincoln found that drawings in sanguine or charcoal were more suitable for children. He was very good with children, telling them stories, putting on the radio or getting their parents to read to them. A sanguine drawing would require between 4 and 6 sittings, a total of 8 to 12 hours. These sanguine drawings are amongst Lincoln's most sensitive work, executed in the manner of Signorina Simi, which in itself owed much to Ingres. Understandably they were very popular.

In 1968 Lincoln was introduced to John Joliffe Tufnell (known as "Bill") of Langleys, Great Waltham, near Chelmsford, Essex. He saw his work at Jaggers and commissioned Lincoln to paint a series of murals over some 20 years. He also commissioned portraits of his staff, all to be executed in sanguine. The cook, the woodsman and the gamekeeper were all drawn by Lincoln over a period of some years.

Emma Curtis, 1967.

Philip Curtis, 1967.

One of Lincoln's last tempera portraits was that of The High Sheriff of Glamorgan, Mrs Sue Williams, painted in full regalia. A more romantic portrait, influenced by the style of Annigoni, was the 1971 portrait of Richard Freemantle. Lincoln had very strong views about portraiture, disliking much of the modern movement, such as Cubist and Futurist portraiture, which he considered betrayed the sitter. Apart from Annigoni, his favourite contemporary portrait painter was the American Andrew Wyeth, whose still lifes he also admired. In fact, he had comparatively little interest in contemporary portraits and apart from visiting, and later taking part in, the Royal Society of Portrait Painters exhibitions, he saw few modern portraits.

Lincoln's best portraits are those where he established a rapport with his sitter; the better the rapport, the better the portrait and a number of portrait commissions led to life-long friendships. This was case with the portrait of the Duchess of Hamilton painted in tempera in 1973. The commission was the result of

Mrs S. Williams, High Sheriff of Glamorgan, 1969.

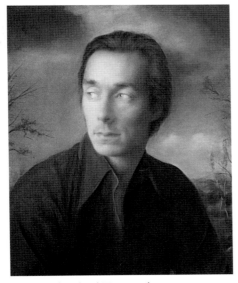

Portrait of Richard Freemantle, 1971.

Study for the portrait of the Duchess of Hamilton. Sanguine and charcoal, 10 x 14 in., collection the Duke of Hamilton, 1973.

meeting Hal Danby, a close friend and business partner of Angus Hamilton, then Lord Clydesdale, who in turn became a friend of Lincoln and Jacqueline Taber. They were invited to stay in East Lothian while painting the Duchess. Lincoln was also commissioned to draw a posthumous portrait of the 14th Duke of Hamilton, whom Rudolf Hess had flown to Scotland to see in 1941.

In 1974 the Tabers met Peter and Ruth Fane through the picture restorer Clare Wilkins to whom they had expressed a desire to have their portraits painted. The Fanes were to become close friends and patrons, commissioning murals for their house and buying paintings at Lincoln's exhibitions. Likewise, the sanguine portrait of Alina Stonor (1977, see page 33) led to Lord Camoys taking an interest in Lincoln's easel paintings.

In the early 1970s Lincoln was charging £250 for an oil or tempera of 20 x 30 inches and £75 for a sanguine drawing, but by 1977 his sanguines were fetching £350 while his oils had also risen. More and more local people were commissioning sanguine portraits and Lincoln was becoming increasingly busy.

Posthumous portrait of the 14th Duke of Hamilton, 1975.

BELOW LEFT: *Peter Fane.* Sanguine. 20 x 14 in., 1974, collection P. W. Fane Esq.

BELOW RIGHT: *Ruth Fane.* Oil on board. 30 x 26 in., 1977, collection P. W. Fane Esq.

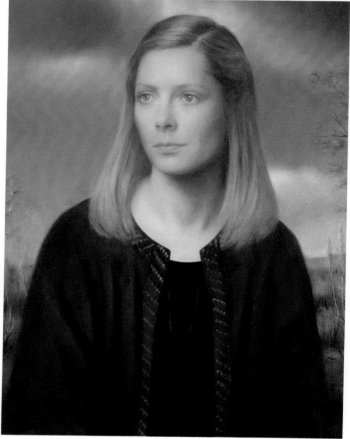

RIGHT: *Lucinda Douglas-Menzies.* Sanguine. 20 x 14 in., 1977, collection Mrs C. Whitworth-Jones.

FAR RIGHT: *Lady Juliet & Helena de Chair.* Sanguine. 20 x 14 in., 1978, collection Lady Juliet Tadgell.

The need to produce enough paintings for his first one-man show at Holkham in 1975 and his first show at the King Street Gallery in 1977 added to the pressure of work. These exhibitions included portrait drawings and in turn led to further commissions. Lord Tanlaw first saw a Lincoln Taber at the Royal Academy, then by chance at the King Street Gallery. This led to portrait commissions, friendship and further patronage. Other fine sanguine portraits of this period include those of Lucinda Douglas-Menzies and her sister, Arabella , and the first double portrait, that of Lady Juliet and Helena de Chair.

BELOW LEFT: *Study for portrait of Monsieur Redier, 1978.*

BELOW RIGHT: *Portrait of John Cobbold, 1978,* collection Philip Hope-Cobbold.

In 1978, through Peter Fane, Lincoln was commissioned to paint the portrait of Monsieur Jean Redier who was President of the French insurance company Le Blanc et de Nicolay, and agent for Carter, Wilkes and Fane. The Tabers spent five days in a hotel in Paris while Lincoln painted in Monsieur Redier's office. He also came over to London for the final touches. The portrait was a great success and was appreciated by the sitter and his family. Another important commission in the same year was the portrait of John Cobbold which had come through friends who had seen Lincoln's murals at Brantham Glebe. John Cobbold was not only the head of the famous family brewing firm, but also chairman of Ipswich Town Football Club which had won the FA Cup in 1978. Lincoln painted his sitter wearing the Ipswich sweater.

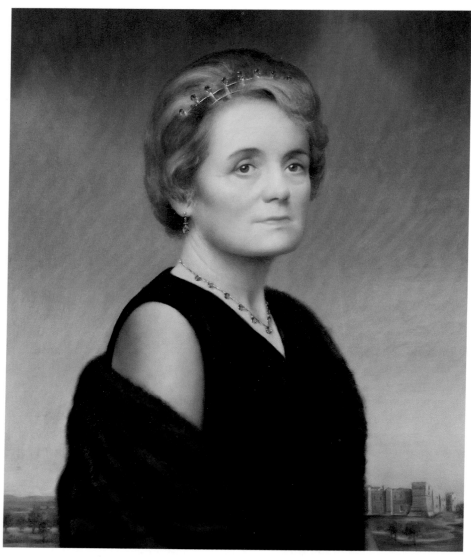

Lady Alport. Oil on board. 30 x 20 in., 1979, collection Lord Alport.

The portrait of Lady Alport was painted under difficult circumstances in 1979. Wife of a former MP for Colchester and later Governor of Rhodesia, Lady Alport was already ill when the portrait was started. A successful portrait, with a view of Colchester Castle in the background, it was unveiled at a party in the Alport's house. Sadly the sitter died 4 years later. In the following year, Lincoln's head and shoulders of Sara Plunket was exhibited at the Royal Society of Portrait Painters in the Mall Galleries: Lincoln also exhibited a self portrait in the same exhibition. Lincoln had been exhibiting at the RP since 1971 when he showed a portrait of Max Ward, and he hoped one day to be elected to the Society. However, competition and rivalries were fierce and Lincoln was never to be elected despite being a regular exhibitor. He was delighted to be elected an Honorary Member of the Society of American Portrait Painters in 1984.

Sir Seymour Egerton, 1981.

A rather unusual commission came in 1981 to paint Sir Seymour Egerton GCVO, head of Coutts Bank and Vice-President for 25 years of the Corporation of Church House. It was an unlikely match, but Lincoln warmed quickly to Sir Seymour, a rapport was established and he greatly enjoyed painting this portrait.

1982, one of Lincoln's busiest years, was dominated by his exhibition at the Savoy Hotel and the portrait of HRH Princess Anne, commissioned by the Fishmongers Company (see page 31). The Company wanted portraits of both Prince Charles and Princess Anne, and Lincoln submitted a portfolio hoping to have the honour to paint the Prince of Wales. However Prince Charles preferred another artist and Lincoln was invited instead to paint Princess Anne for the agreed price of £4000. Lincoln started the portrait as usual by making careful sanguine drawings before transferring to board. The sittings took place at Gatcombe Park

Study for HRH Princess Anne. Sanguine. 20 x 14 in., 1982, collection Captain Mark Philips.

and Buckingham Palace as well as at the studio in Thurloe Place which he was sharing with Richard Foster, a fellow student from the Signorina Simi days. The security was intense with detectives and dogs visiting the studio well in advance of the sittings. The Yellow Drawing Room in Buckingham Palace was made available with druggets on the floors, and Lincoln helped the Princess choose a simple dress and jewellery given to her by the Fishmongers Company. Lincoln was surprised at how the staff of Buckingham Palace helped his task by preparing the Yellow Drawing Room with an easel, carafes of water and, when the Princess could not sit, a dummy clothed in the dress for the portrait. In a letter of 5th November 1982, he wrote:

> Princess Anne is still in Africa but I've been spending a lot of time at Buckingham Palace painting her dress and jewellery. They won't let me out of the Palace with the jewellery. I wonder why!!

The background to the portrait was of Gatcombe Park and to soften the lines, Lincoln painted a dead elm. When Princess Anne saw the portrait she commented that she did not have dead elms at Gatcombe, and Lincoln had to paint in some leaves! As a joke in his letters to Peter Fane he referred to himself as "court painter" and "court sweeper and cleaner", but despite the Royal commission, Lincoln continued to be short of money. He hoped to sell some of the preparatory drawings for the portrait and wrote to Peter Fane on 4th December 1982:

> I have several finished drawings of HRH done from life as studies for my finished portrait and if you know of anyone interested, that would bring head nearer the surface. I was thinking of £1500 each, framed and mounted and inscribed Buckingham palace and date. Does that sound reasonable?

The final portrait was a success and generated much favourable press comment. The portrait was not accepted by the Royal Society of Portrait Painters, a victim no doubt of intense rivalries, and Lincoln decided to exhibit it at a special exhibition of contemporary portraits at the King Street Galleries. The commission to draw the Durlacher family was one of the results of this exhibition, but demands for portraits and murals increased the pressure on Lincoln who, always a *bon viveur*, was beginning to drink too much.

Natasha Durlacher. Sanguine. 20 x 14 in., 1983, collection Mr and Mrs R. Durlacher.

HRH Princess Anne. Oil on board. 40 x 30 in., 1982, collection the Worshipful Company of Fishmongers.

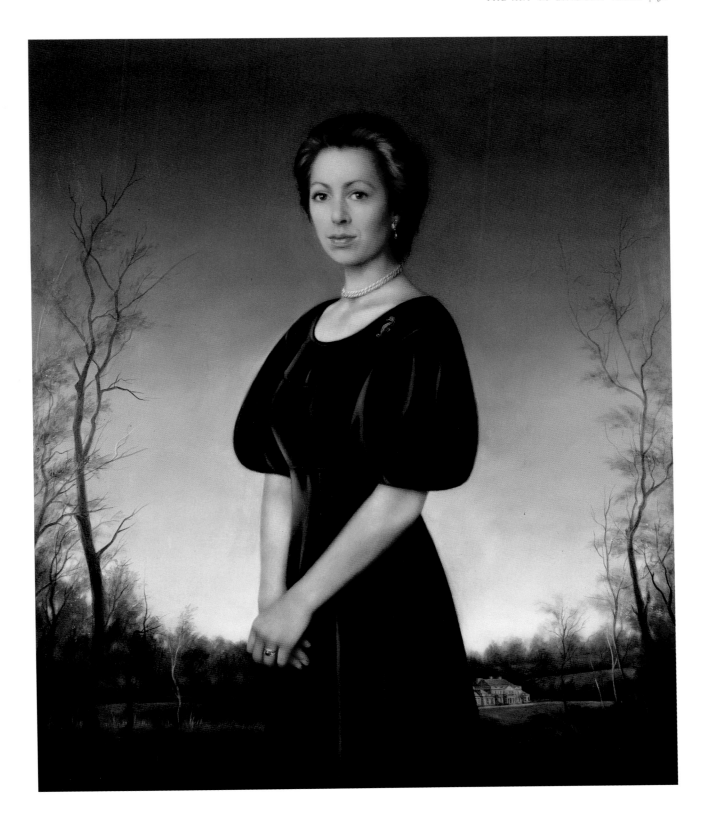

Lucy Sanderson. Sanguine. 1985, collection Dr and Mrs John Sanderson.

Emily Pritchard-Gordon. Sanguine. 20 x 14 in., 1987, collection Mr and Mrs G. Pritchard-Gordon.

Tara. Sanguine. 20 x 14 in., 1982, collection Jonathan Coe Esq.

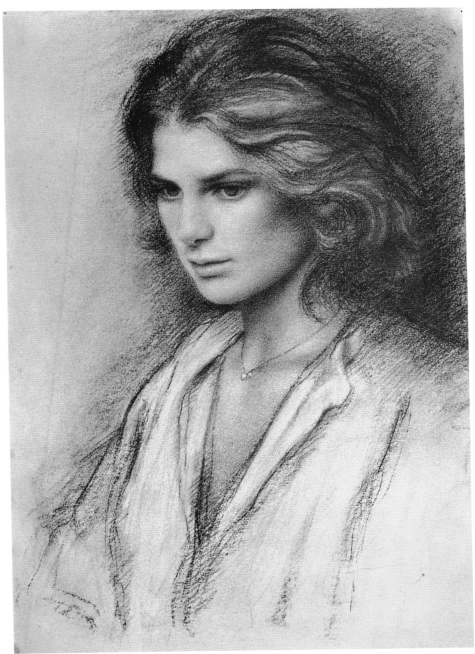

Sara. Sanguine. 20 x 14 in., 1979,
collection Mr and Mrs L. Cumani.

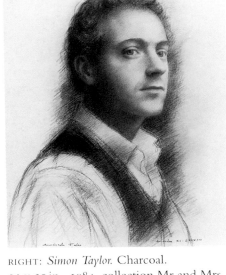

RIGHT: *Simon Taylor.* Charcoal.
25 x 20 in., 1984, collection Mr and Mrs
Simon Taylor.

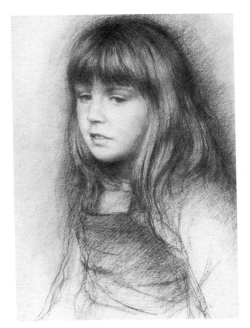

Alina. Sanguine. 20 x 14 in., 1977,
collection Lord and Lady Camoys.

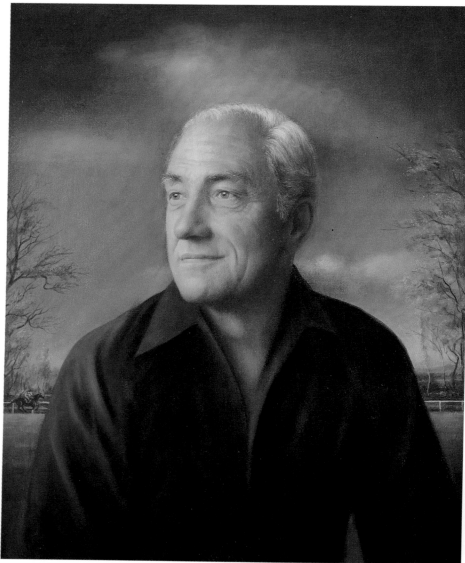

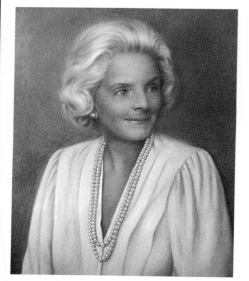

Sir Richard Brooke. Oil on board. 27 x 20 in., 1984, collection Sir David Brooke.

Portrait of Peggy Byrnes, 1985.

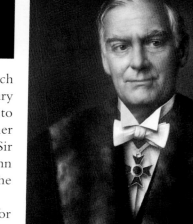

Portrait of John Hailwood, 1988.

1984 saw the portrait of Sir Richard Brooke (above) painted mostly at his French house near Grasse. Sir Richard's family had collected portraits from the 16th century onwards including Raeburns and Gainsboroughs, and Lincoln was honoured to be hung in their company. This portrait, like so many others, led to a further commission, the portrait of Peggy Byrnes an American business associate of Sir Richard's son. In the following year Lincoln flew to St Lucia to paint John Hailwood, the Fyffes banana magnate who had seen Lincoln's portraits at the King Street Galleries.

One of the problems that Lincoln encountered with a portrait was asking for money as the commission progressed, especially if, as often happened, the commission led to a friendship between artist and sitter. This problem was solved

when Jonathan Coe, an artist's agent who specialised in portraits, became Lincoln's agent. He arranged for commissions and sittings, took advances and progress payments, receiving in return a commission of 10%.

The nudes

At Signorina Simi's Lincoln had regularly drawn nudes from life and he was to continue this practice throughout his life. Often the pressure of portrait and mural commissions meant that he had no spare time to draw from life, but he would always return to the nude whenever possible. After long periods without a model he would find that it took some time to get his eye back in. In 1981 he planned to hold an exhibition devoted entirely to nudes, but this never materialised due to the pressure of other work. Most of his nudes are drawings but he also did more ambitious works in oil such as the Barbara Gerrard portrait. Lincoln's nudes, especially his superb drawings, represent some of his finest work.

Jacqueline would often pose for her husband when he had time and he also had a number of other models including Miranda, an art student and a good sitter

BELOW LEFT: *Jacqueline*. Sanguine. 20 x 14 in., 1979, collection Mr Sadaghani.

BELOW RIGHT: *Standing nude*. Charcoal and pencil. 25 x 16 in., 1981, collection Mrs D. Wolfers.

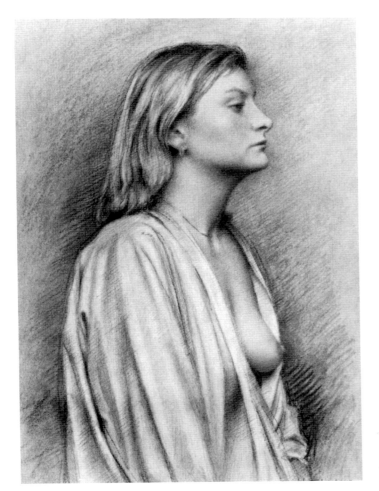

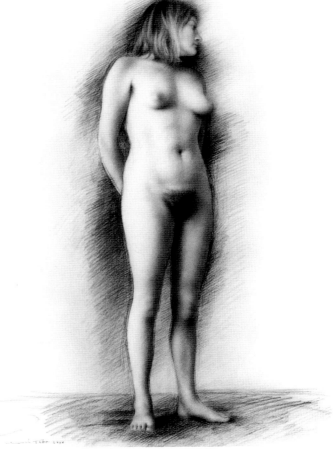

who knew exactly what an artist required of his model. Other models include Tara Howard and Carol Dawson.

In June 1978 Lincoln received a letter from Robert Harling, editor of *House and Garden*:

> Earlier this week I was staying at Natalie Bevan's cottage in Aldeburgh and I saw a drawing by yourself of a reclining nude. I thought the drawing quite beautiful. So beautiful, indeed, that I am emboldened to make a request. Briefly, I write novels mainly against a newspaper background... A new novel, entitled "The Summer Portrait" – first of a projected trilogy – is about a successful portrait artist who is involved with two young women, either of whom might be symbolised by your drawing. To that end I would dearly like to use the drawing for the dust wrapper of the book.

And thus, a drawing of Jacqueline lying on a bed, appeared spread across the dust wrapper of "The Summer Portrait" (see page 37). Despite the cover, the book did not become a best seller.

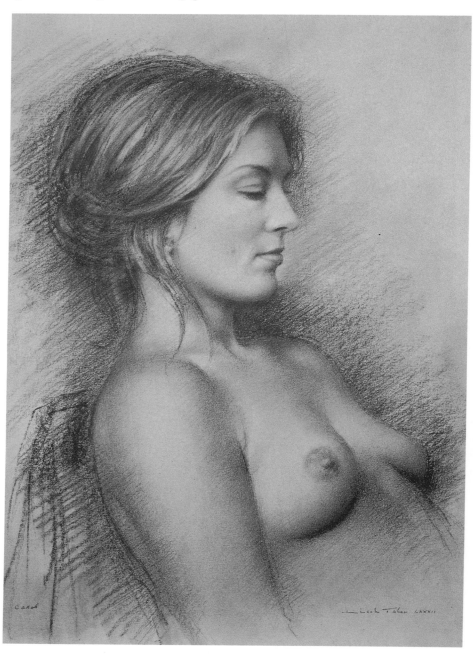

Carol. Sanguine. 20 x 14 in., 1981, collection Mrs D. Wolfers.

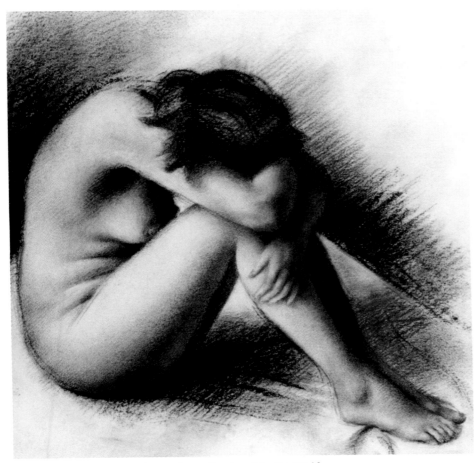

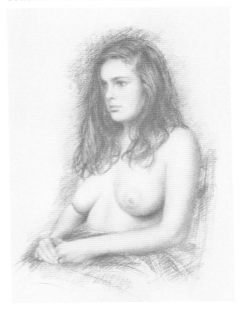

Tara. Sanguine. 20 x 14 in., 1982, collection Antonio Tomma.

Nude. Sanguine. 14 x 14 in., 1982, collection Mrs D. Wolfers.

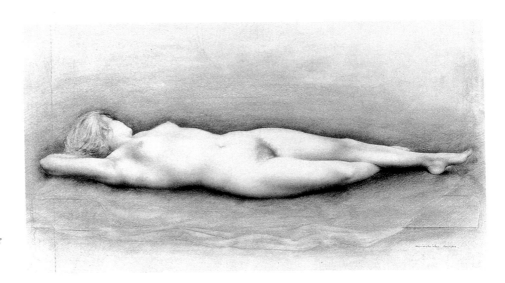

Reclining nude. Used for the cover of *The Summer Portrait*. Charcoal. 30 x 20 in., 1970, collection Mrs N. Barclay.

The Murals

The first mural that Lincoln painted in England was for his future parents-in-law at Jaggers in Fingringhoe. Painted in the autumn of 1965, it was a portrait of Jacqueline sitting on a wall with a landscape, influenced by the style of Annigoni, in the background. Jacqueline remembers sitting for hours for the portrait, her feet blue with cold. The mural, which measured 9 x 15 ft was in an outbuilding which was later converted into a painting studio. Lincoln painted most of it out as he needed a plain background.

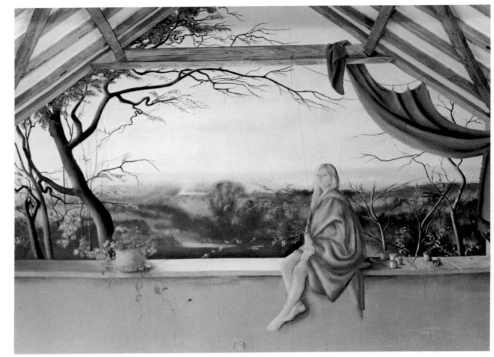

ABOVE: *The mural at Jaggers, 1965.*

BELOW: *Beaumont Hall mural.* Tempera on board. 20 x 36 in., 1967, collection Mrs B. Williamson.

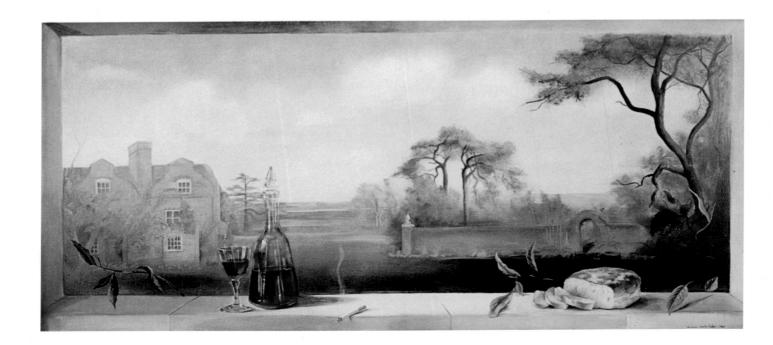

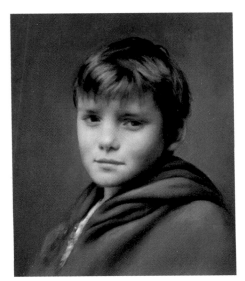

Lincoln Taber Jr. Oil on board. 20 x 36 in., 1984, collection Mrs D. Wolfers.

In the following year, Lincoln was commissioned to paint a mural panel at Beaumont Hall for a friend of the Birch family, Colonel T. Williamson. It depicts a landscape with Beaumont Hall seen over a wall on which is sitting a painted still life of wine and bread. This motif of a wall or ledge with a exquisitely painted still life in the foreground was to become a very typical element in Lincoln's murals.

A more imaginative commission arose in 1968 when Simon and Bettine Birch asked Lincoln to decorate the dining room at their new house, Brantham Glebe. The room was designed by Simon Birch, turning a rather uninteresting space into an octagonal dining room in the style of Batty Langley's "Mousetrap Gothic" at Strawberry Hill. Against a decorative gothic interior, Lincoln painted a series of imaginative Suffolk landscapes using various trompe-l'oeil effects, including a gun propped against the wall. The project took two years to complete because Lincoln was involved in other commissions as well as having family commitments. Their son, Lincoln Junior, was born in June 1970.

Lincoln was fortunate in having devoted patrons who commissioned work over a number of years. One such was Bill Tufnell who had bought the former Post Office in Great Waltham and was converting it into a home, called the Guild Hall. Starting in 1968, Lincoln did a series of trompe-l'oeil panels of fake

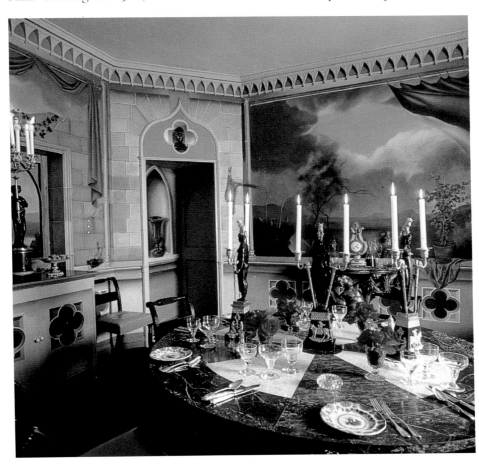

Brantham Glebe mural. Tempera on plaster. 1968–1970, commissioned by Mr and Mrs Simon Birch.

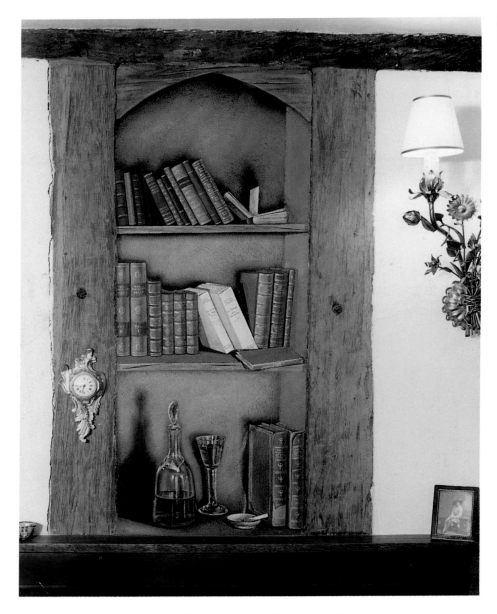

Bookshelves at the Guild Hall, Great Waltham, 1969.

stonework, drapes, book shelves, and two Pompeian doors, not to mention a painted ash tray with a half smoked cigarette. Bill Tufnell was impressed with Lincoln's wide range of abilities and commissioned him to produce a number of copies of famous artists including David, Memling, Canaletto, Botticelli and the still life painter Le Long. It greatly amused Tufnell to show these copies to his friends, and for a number of years he was Lincoln's most important patron. Jacqueline recalls:

> Bill was so enthused by Lincoln's work that he thought it would be a tremendous joke to commission him to do copies of paintings he really liked.

Dutch still life copy. Oil on copper, 1971.

Roman view at South House, 1976.

He put them in magnificent antique frames he bought and then had regilded by his resident gilder. He would then say to his friends "Don't you think this David I have just bought is magnificent". His few remaining friends were far too intimidated to question him about it as he did have a wonderful collection of Chelsea and some very fine pieces of furniture. It must be admitted, however, that Lincoln began to have reservations painting so many copies!

In 1972 Bill Tufnell moved to South House in Great Waltham, and Lincoln set about decorating the new house. He was to work on South House on and off over a period of 8 years, starting in 1972 with a Venetian bedroom. This room was decorated with a series of pastiches of Neapolitan, Tuscan and Venetian landscapes, alternating with painted niches and drapes. He returned to work in South House in 1973 and 1974 when he decorated the Dining Room depicting a large landscape with a wide river, not unlike the Po in Northern Italy, and pots of flowers on a wall in the foreground. A further bedroom was painted in 1976 using a pastiche of the Spanish Steps in Rome and African violets from Bill Tufnell's conservatory in the foreground. A rather unusual commission in 1980–1 was to paint the interior of Tufnell's Beaters' Lodge, which was in fact a small Essex weather board outbuilding in the woods of the Langley's estate which Bill Tufnell owned. Lincoln did a particularly successful mural of a Welsh dresser with bottles and a brace of pheasants.

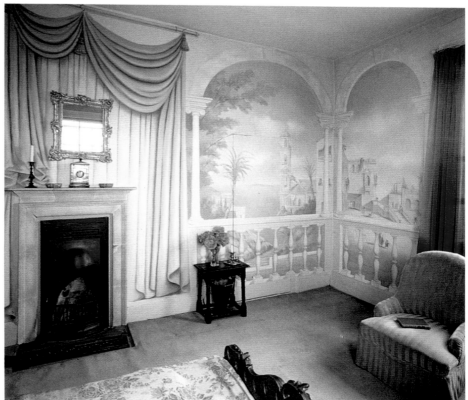

Venetian bedroom mural at South House. Tempera on plaster. 1972, commissioned by J. J. Tufnell Esq.

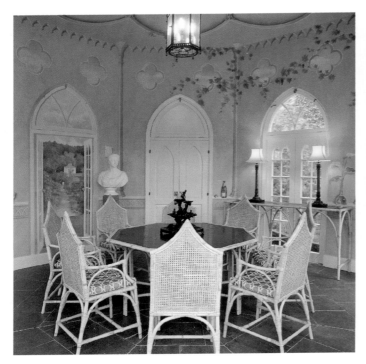

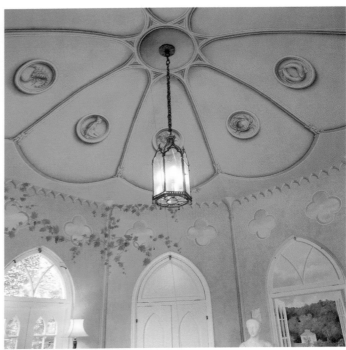

A number of further commissions came through Bill Tufnell including mural decorations for Leeze Priory in Essex and the dining room at 55 Sloane Street in London. The latter was painted in 1973 for Mrs Stuart Paton, the mother-in-law of George Judd, a friend of Bill Tufnell and a partner in Strutt and Parker, the East Anglian firm of estate agents. Here Lincoln used an Italianate landscape seen through classical columns, with a balustrade in the foreground. He also painted trompe-l'oeil bookshelves.

During 1975 and 1976 Lincoln was working on one of his most successful mural projects, the gazebo at Colby Lodge, Pembrokeshire, now owned by the Welsh National Trust. Colby Lodge belonged to Peter Chance, chairman of Christies and a close friend of Simon Birch who was responsible for designing the octagonal summer house. The gazebo demanded a light and witty theme which Lincoln created by painting a clematis climbing up the walls, beneath which was a ledge and a dado of flowers. On the ledge he painted glasses of wine, a bottle of champagne and a silver mug, while higher up he painted a series of fake quatrefoil windows, with a heron flying past one of them. The gazebo had doors opening onto the garden, and where a real door was not possible, Lincoln painted in a false one with a view of the path leading down the garden. He returned in 1976 to paint the ceiling using eight signs of the zodiac which represented the eight people involved in the project, including Jacqueline who gilded the outside pinnacle. Rather as in the octagonal dining room at Brantham Glebe, the whole character of the project is Strawberry Hill Gothic; light, elegant and amusing.

In 1977 Lincoln concentrated on his one-man show at the King Street Galleries and painted no murals, but in 1978 he was commissioned to paint a mural for

Colby Lodge mural. Tempera on Plaster. 1975, commissioned by I. O. Chance Esq.

Details from Colby Lodge mural.

Poons Restaurant in Covent Garden where Lord Tanlaw was a partner. As the restaurant was busy during the day, Lincoln had to arrive to start work at midnight, and he usually found bowls of food left out by the waiters. Fortified by these, he worked until the early morning. The restaurant has changed hands and the mural lost, but it was a successful composition showing a mountainous Chinese landscape behind with a balustrade in the foreground on which were placed a lobster, a bowl of rice and a teapot which, unable to resist a visual joke, Lincoln had painted on its side, the tea leaves spilt on the balustrade. The Poons considered this a bad omen and had him paint it out. A nice Chinese touch to the mural was a bunch of sausages hanging from the top to dry in the wind.

Lincoln was also involved in a mural at Capel Hall, Trimley in Suffolk for John Cobbold whose portrait he was painting at the same time. This decorative scheme was dominated by a large Suffolk landscape, along with painted cupboards which contained a bust of the patron.

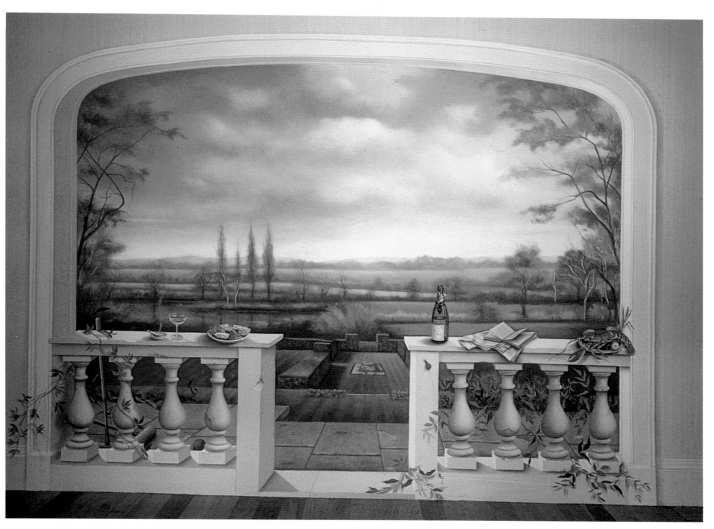

Capel Hall mural. Tempera on Plaster. 1978, commissioned by J. Cobbold Esq.

The second one-man show at the King Street Galleries in 1979 meant that Lincoln had to devote himself to easel paintings, but in 1980 Lincoln's most important commission was secured through Giles Shepard, a friend of Simon Birch, to decorate the Thames Foyer at the Savoy Hotel in London. In 1978 Lincoln had painted two small oils of the Thames for the Savoy which were used for their Christmas card, and he was asked to paint Suffolk landscapes on three walls of the hotel's Thames Foyer.

Detail from Savoy mural, Thames Foyer, showing cockroach. Tempera on Plaster. 1980.

The three landscape panels were interspersed with trompe-l'oeil decorations such as marble niches and his favourite marble balustrade with objects on the ledge. These included a plate of oysters and a brace of pheasants. Always enjoying a visual joke, Lincoln took a bet with Antony Stanley Clarke of a case of champagne that he would dare paint a cockroach on the marble. He did; he won the champagne; and the cockroach is still there. He also painted a fly on the wall which has not survived the test of time, as the waiters would automatically flick at it with their napkins! For this commission Lincoln was paid £6000 with a further £2000 in kind, to be spent on dining at the Savoy.

In 1984 Lincoln returned to the Savoy to decorate the Beaufort Room, a commission which was worth £8900. Before starting work, he produced a

Portrait of Anthony Stanley Clarke, 1988.

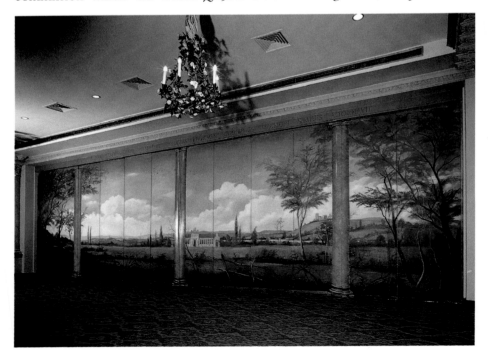

Savoy mural, Beaufort Room. Tempera on Plaster. 1984. By kind permission of the Savoy Group.

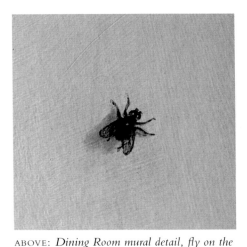

ABOVE: *Dining Room mural detail, fly on the wall.* Tempera on Plaster. 1985, commissioned by P. W. Fane Esq.

RIGHT: *Dining Room mural, over door.* Tempera on Plaster. 1985, commissioned by P. W. Fane Esq.

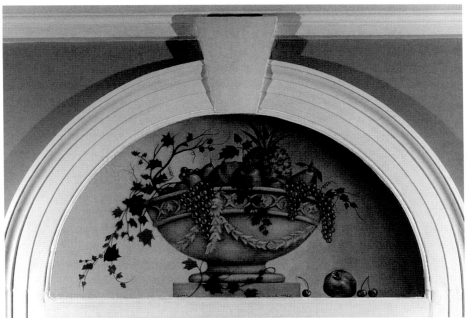

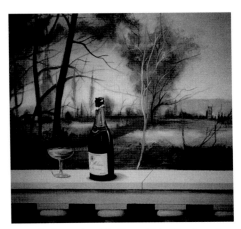

Detail of mural at Dedham Vale Hotel, 1987.

number of studies for the project, one of which, a landscape of Dedham Vale, was bought by the hotel and hangs in the restaurant. Lincoln composed a series of imaginary landscapes broadly based on his beloved Suffolk landscape with a fox hunt in one corner and, as a play of words on the name of the room, a fort in another corner. Working at the Savoy was a highly enjoyable experience for Lincoln. Not only did he strike up a good relationship with the restaurant manager, Antonio Celant, who helped him design and make frames for his easel pictures, but he was also regularly visited and fêted by friends. In fact, he became something of a celebrity at the Savoy.

1985 saw a small but exquisite project to decorate the dining room of Peter and Ruth Fane's house in Cheyne Row. With the help of Jacqueline, Lincoln painted fake columns around the room, a landscape overdoor decoration, and his favourite fly on the wall. The scheme fits perfectly into the elegant Queen Anne architecture of the house. At the time Lincoln was recovering from his motorcycle accident on Mustique and was undergoing hydrotherapy treatment. In a letter to Peter Fane dated 6th June 1985 he wrote:

> I'm becoming stronger by the minute, and walking without a cane now, but judging by my progress, I'd better avoid a stepladder for another few weeks.

A more demanding and difficult project was to decorate the bar at the Dedham Vale Hotel in 1987 for Gerald Milson, the owner, who had seen the Savoy murals. One problem was that the bar could not be closed, so Lincoln and Jacqueline became in effect a regular cabaret for the entertainment of the guests. Another problem was the size of the room which required some 50 columns beneath the balustrade. Lincoln did the first column as a pattern leaving Jacqueline to paint

the remaining 49 while he got on with the Suffolk landscapes above. However, at £10,000, this was the most valuable mural project to date. Lincoln describes the scale of the project in a letter to his mother of 2nd April 1987:

> Dear Mom,
> Sorry I haven't written sooner, but things have been absolutely hectic in the last couple of months painting this very large mural for the Dedham Vale Hotel, which thank goodness is now finished and everyone is delighted with it. It was a real job, and I'd arrive back in the evenings completely exhausted...

Lincoln's final mural was painted for Linda Lines in the dining room of her flat in Whitehall Court in 1988, the commission coming through Ruth Fane. The subject was Richmond Park seen across a low balustrade with a ledge and a painted still life. By this time, Lincoln's health was deteriorating and Jacqueline finished the project after his death.

Painting the mural at Whitehall Court, 1988.

Stylistically, Lincoln's murals were influenced by both Annigoni and John Constable. Lincoln was influenced by Annigoni's use of columns, balustrades, still lifes and drapes in his frescoes, while also responding to Constable's broad handling of the East Anglian landscape, especially his sweeping skies. While Annigoni worked in traditional fresco, Lincoln preferred to use what the Italians called "tempera lavabile", an acrylic based tempera that could be washed. This was manufactured by Morgan's and was sold in Italy to house painters who wanted to tint their paints themselves rather than buying commercially coloured paint. Morgan's paint was very strong and was diluted 40 to 1, but it could only be bought in Italy and every pot had to be brought back by Lincoln and Jacqueline from their regular trips to Florence. Lincoln used a variety of painting instruments including small round, soft brushes of badger hair for details and sponges and 3 inch brushes for wider areas. Finishing was sometimes done with expensive sable brushes, and he later discovered the value of cheaper nylon brushes.

For most of the murals Lincoln painted directly onto the plaster, without preliminary underpainting, and he quite liked the effect of painting directly onto pink un-primed plaster. While he hated doing preliminary cartoons for a mural, Lincoln usually made preliminary oil studies for the landscapes. The columns and balustrades were carefully drawn before painting began. Once he had started, Lincoln would paint very fast as there was often a time limit on the project. He remained, however, a perfectionist and was never finished until entirely happy with the result. Not all the murals were painted directly onto plaster; many were painted on gessoed board which was then fixed onto the walls. During most of the mural commissions, Lincoln was helped by Jacqueline who mixed colours, helped with preliminary architectural drawings and often spent days painting columns, balustrades and architectural motifs.

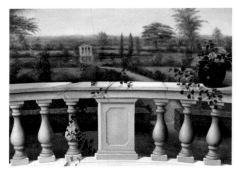

Detail of the mural at Whitehall Court.

Lincoln greatly enjoyed the mural commissions and was always excited to start on "a bit of trompe"; the results are amongst his most successful work. He managed to combine a lyrical approach to landscape within a structured architectural framework, while at the same time providing some visual humour. His murals are freshly handled, witty and elegant, an unusual combination.

The easel paintings

In addition to fulfilling portrait and mural commissions, Lincoln held a number of one-man shows of his smaller easel paintings. The pressure that these shows created was considerable, not only on his time but also on his finances, because for at least a year before an exhibition, while working up a body of good pictures, Lincoln was unable to take on commissions. The exhibitions were therefore something of a strain on himself and his family.

His first one-man show in England was in 1975 at the Ancient House Gallery in Holkham, Norfolk. This was a great success and as a result he was invited to hold another one-man at the King Street Gallery in St James's, London followed by two more shows at the King Street Gallery in 1979 and 1984. All these shows were successful and were almost total sell-outs. The owner of the gallery, Nöel Napier-Ford recalls:

> My first acquaintance with Lincoln's paintings was through the Royal Academy in 1975 where I encountered his trompe-l'oeil painting of a reverse canvas. At that time representational painting had not returned to favour to the extent that it has today but, then searching for new artists, I found it refreshing to come across work where disciplined drawing and meticulous painting were brought together with such splendid effect. There was a good deal more to that picture however, and, as I began to know them later, his other still lifes. Exact observation of the object painted was one characteristic, an acute sense of light another, but there was something else, a surrealist overtone, setting it apart from others in this genre and giving Lincoln's work its special character. That first encounter with Lincoln's painting led quickly to an invitation to

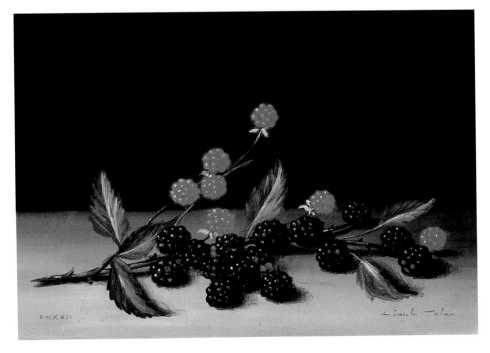

Blackberries. Oil on board. 5 x 7 in., 1982, collection Mr and Mrs R. English.

hold a one-man show at the King Street Galleries, an outstanding success, (as were all his subsequent one-man exhibitions at the gallery) and, of course, to frequent visits to his home and studio on the edge of the Essex marshes where, with his wife Jacqueline, there existed an oasis of creative talent. Thinking I was to meet a painter of still-lifes it was an initial surprise to find that he was an American, a muralist, a portraitist and landscape painter all rolled into one. None of that had been indicated to me by that one exhibit in the Summer show of 1975, but what a bonus to a gallery owner, to discover such diversity in one artist. Lincoln's American origins helped to explain what I saw as his special approach to still-life: the almost unreal depiction of everyday objects seemed to refer back to the great tradition of the North American School but, through his eyes it all came out very differently, less naive, more sophisticated. Perhaps a key to that was the artistic training, received eventually in Europe, and an acknowledged debt both to the art and advice of Salvador Dali.

Surrounded as Lincoln was by the artistic heritage of Florence it is not surprising that the disciplines he absorbed in that environment show in his art. His sanguine portraits and pencil drawings, beautifully executed with a gentleness that gives them their distinction. So too his oils and murals, but how distinctively different these influences are when interpreted by the hand of Lincoln Taber, and how exceptional they seemed back in 1975, at a time when the London art schools appeared to have abandoned traditional drawing. To his lasting credit Lincoln's work is as fresh and surprising today as it was when I first came across him in 1975.

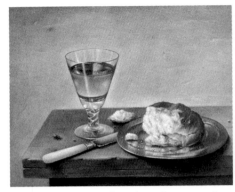

Bread and Wine. Oil on board. 10 x 12 in., 1975, collection Robin Leslie Esq.

Gulls Eggs. Oil on board. 6 x 8 in., 1976, collection Lady Juliet Tadgell.

In addition to the one-man shows at the King Street Gallery, Lincoln held a one-man at the Savoy Hotel in 1982. He arranged this himself although it was hung for him by Nöel Napier-Ford. The intention was twofold: to let people see his murals at the Savoy at the same time as visiting the exhibition and to avoid gallery commission. The first aim was fulfilled, but the second was less successful as arranging the exhibition took much time and proved very expensive. Lincoln was lent £8000 by Peter Fane in October 1981 to help pay for the expenses involved and to tide him over a period without commission income. In a letter Lincoln thanked his patron:

> Thank you very much and I'm very grateful. If things don't go well and the Communists take over the country, don't worry, I'll give it back to you in the summer (with a present).

In fact the present or "interest" was a sanguine portrait of the Fanes' son, Max.

In 1984 Lincoln returned to the King Street Galleries for his final London show, which was again a great success. The catalogue contained an introduction by his former master, Pietro Annigoni:

> I first met Lincoln in 1961 when he came to my studio in Borgo degli Albizi. He brought some of his drawings to show me, and soon afterwards joined me as a pupil.

Maximilian Fane. Sanguine. 20 x 14 in., 1984, collection Mr and Mrs P. W. Fane.

Whilst studying in my studio he preferred working in a small room upstairs, right under the eaves, where it became terribly cold during the winter months; however he seemed to endure the cold just as well as he endured the strict discipline I imposed upon him. At that time his considerable talent lay dormant within him, but it developed slowly but surely like a plant which had difficulty breaking through the earth and later developed vigorously and flourished with exuberant freshness.

Today we see and admire its fruits.

For my own part I can honestly say that I hold Lincoln Taber's work in the highest esteem and in particular his portraits, which are beautifully drawn and executed. I find them often very moving by virtue of their profound sentiment.

Lincoln also held two smaller exhibitions: in 1982 he took part in a two-man show at the Ivor and Joan Weiss Gallery in Kelvedon, Essex and in 1985 he held a small one-man show at the Hotel Twin Dolphin, Cabo San Lucas, Mexico,

Landscapes

Lincoln had painted landscapes since his days in Florence when he would go out into the Tuscan landscape and work on the spot. He continued to paint landscapes *en plein aire* throughout his life, and often when working on a major mural commission, he would take time out to capture the surrounding landscape.

The Essex marshes around Fingrinhoe, wet land leading down towards the Colne Estuary, were the source of many of his paintings. It was a countryside

Suffolk landscape. Oil on board. 25 x 50 in., 1982, collection Savoy Hotel.

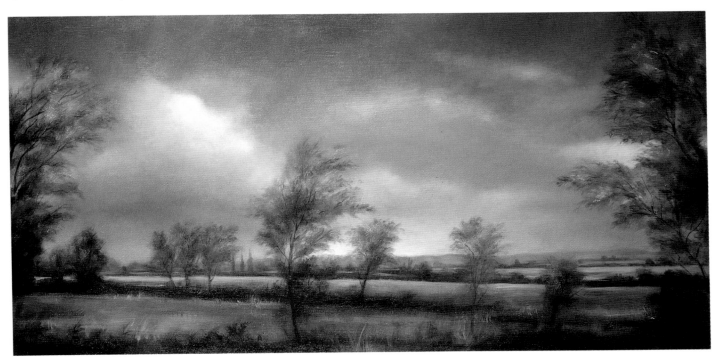

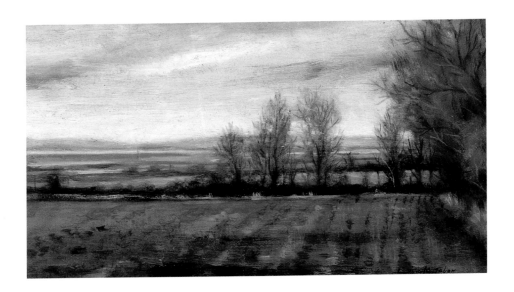

ABOVE: *Essex marshes.* Oil on board. 10 x 14 in., 1977, collection P. W. Fane Esq.

BELOW: *Pembrokeshire landscape.* Oil on canvas. 36 x 40 in., 1979, collection
P. W. Fane Esq.

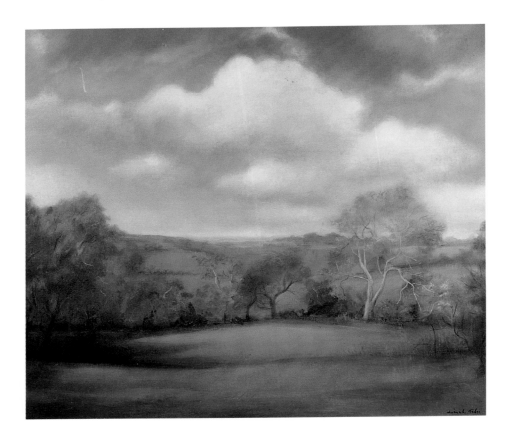

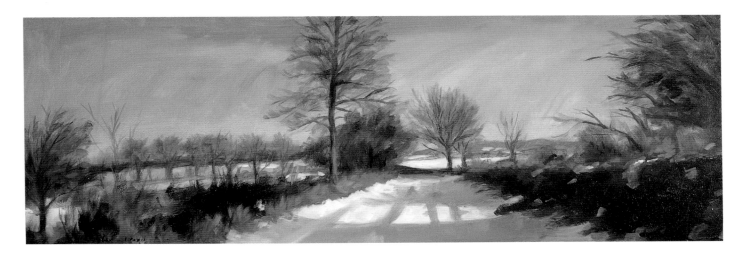

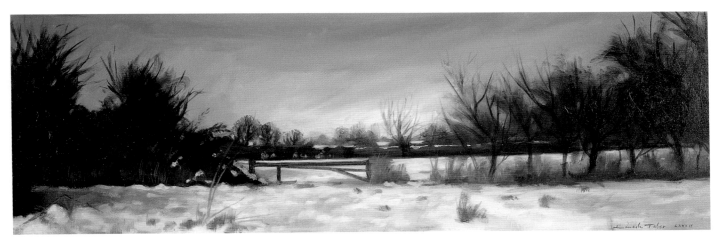

TOP: *Winter, Fingringhoe.* Oil on board.
6 x 18 in., 1982, collection Mrs J. Cohen.

ABOVE: *Winter, Fingringhoe.* Oil on board.
6 x 18 in., 1982, collection
Mrs J. Cohen.

which had inspired John Constable and many East Anglian painters , and Lincoln soon fell to its extraordinary charms. Not a beautiful landscape, it has a touch of wildness and drama in the broad sweep of the skies, but it became a central part of Lincoln's landscapes. Most evenings, he and Jacqueline would walk across the marshes admiring what they called "a Taber sky" or discussing the sunset. Lincoln also painted in Dedham Vale nearby, while at other times he would venture further north into Suffolk. Snow was a special favourite for Lincoln and he would work outside 'despite the cold', to capture the extraordinary light created by it.

In the mid-1970's while working on Peter Chance's gazebo in Pembrokeshire, Lincoln produced a number of fine landscapes of the surrounding countryside. Later in his career when he had the studio in Broadhurst Gardens in Swiss Cottage, London, he would paint in Regents Park and Primrose Hill. He also returned regularly to Florence and continued to be attracted by the Tuscan landscape, and in addition painting the Veneto landscape in 1984 when he stayed at Polcenigo the home of Antonio Celant, restaurant manager of the Savoy Hotel.

Trompe-l'oeil and still life

Lincoln greatly enjoyed the American school of still life and trompe-l'oeil painters which continued well into the 20th century with artists such as John Haberle (1858–1933), William Michael Harnett (1848–1892) and John Frederic Peto (1854–1907). There was often a homespun quality about their work which revealed a lack of training, qualities not shared by Lincoln whose trompe-l'oeil work was always meticulously drawn. At the same time, he did admire the Americans' method of putting together a number of rather ordinary objects in an interesting manner.

He also admired a number of European trompe-l'oeil artists, including many of the Dutch artists whose work he saw at the home of his parents-in-law who were keen collectors of Dutch still life. He admired the French painter Jean-Baptiste Oudry (1686–1755) whose painting of a white swan against a white background he particularly loved. This was to be the inspiration for Lincoln's *Dead Swan* (1982).

Pigeons. Oil on board. 20 x 14 in., 1975, collection A. L. Taber III.

Dead Swan. Tempera on board. 48 x 30 in., 1982, collection Mr and Mrs T. Conant.

OPPOSITE: *The Fishwife.* Oil on board. 20 x 14 in., 1975, Jan Murphy Gallery, Australia.

Poor Artists Palette. Oil on board. 30 x 28 in., 1982, collection Hal Danby Esq.

The swan had died by flying into an electricity pylon and had been kept frozen at Colchester Natural History Museum awaiting a taxidermist. Lincoln was given the swan and proceeded to paint it quite slowly in tempera, so that by the time the picture was finished, the swan was becoming somewhat odoriferous.

Perhaps the most memorable of Lincoln's trompe-l'oeils are *The Collector* (p.56), *The Fishwife* (p.54), *The Umbrella* (p.57) and *Poor Artist's Palette* (below). *The Fishwife* was exhibited at the 1975 Royal Academy Summer Exhibition and was used on the cover of Celestine Dars' "Images of Deception. The Art of Trompe-l'oeil" (Phaidon 1979). It depicts the back of a painting apparently accepted by the Royal Academy selection committee, the title written on the label being the only reference to a fishwife. The image, complete with the inevitable fly, is audacious and amusing at the same time, and seen in context of the Summer exhibition, it is also quite provocative. *Poor Artist's Palette* 1982 continues the theme of the unseen and unknown aspects of the artist's life and work replacing the finished product in the eyes of the public.

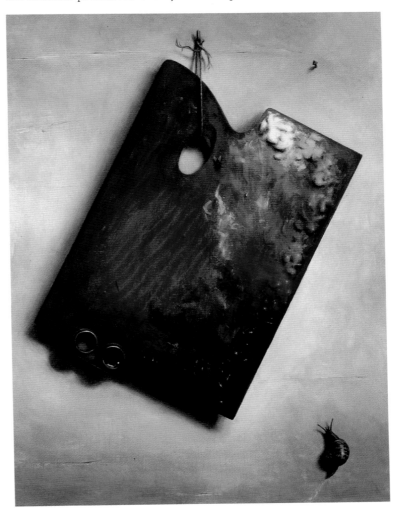

The Collector. Oil on board. 30 x 25 in., 1977, collection Lord and Lady Tanlaw.

The Collector was exhibited at the 1977 Royal Academy and bought by Lord Tanlaw. Insects and butterflies had always been of great interest to Lincoln, who would often keep a stag beetle or wasp in the refrigerator. He painted many small studies of bumblebees, bluebottles, gad flies, moths, hornets, cabbage whites, red admirals, and many different types of beetles. His paintings of insects became famous and people would give him interesting specimens they had found. On one occasion he kept a dragonfly in the refrigerator for several weeks so that it would not lose its colour. These represent some of his finest work, beautifully executed in a meticulous, but fluent style and often presented in large frames which he had made and decorated himself.

The Green Umbrella was painted in 1984 and reveals a debt to the American still life painters with their interest in very ordinary objects painted in such a way as to show them in a different light. Other subjects in which Lincoln reveals an influence of both American and French still life painters are his braces of pheasants, both painted and carved examples of which he saw at the Birch's home.

Fish and shell fish also fascinated Lincoln, their colours and textures providing a real challenge to his representational skills. He painted many small still lifes of

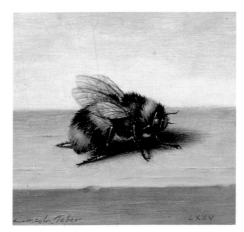

Bumblebee. Oil on board. 3 x 2 in., 1975, collection P. W. Fane Esq.

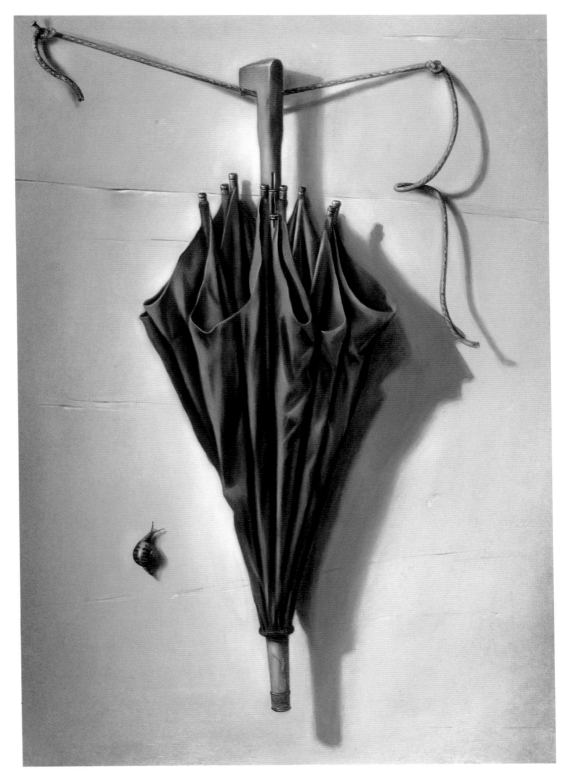

The Green Umbrella. Oil on board. 40 x 30 in., 1984, collection Oliver Eley Esq.

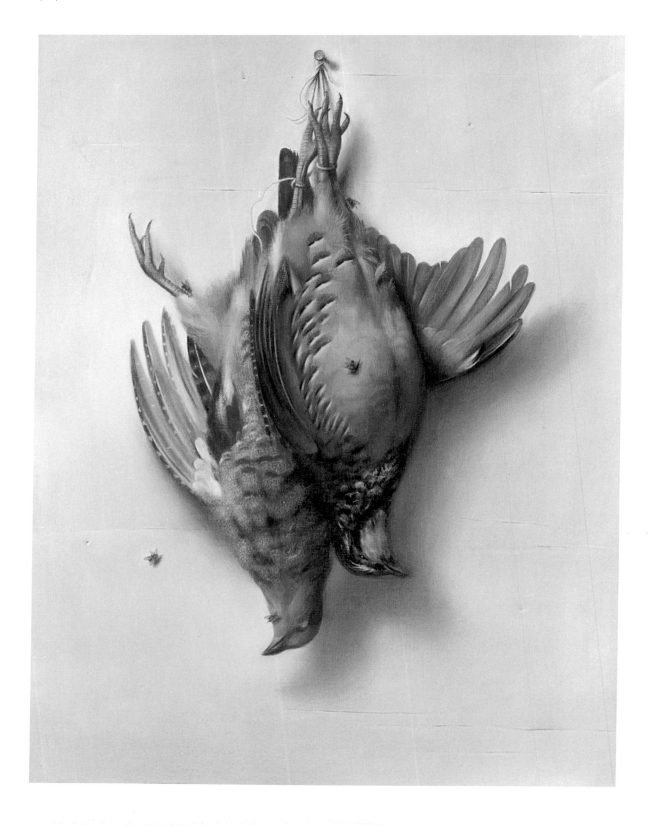

Mackerel. 1975, collection Mr and Mrs
N. Beresford-Jones.

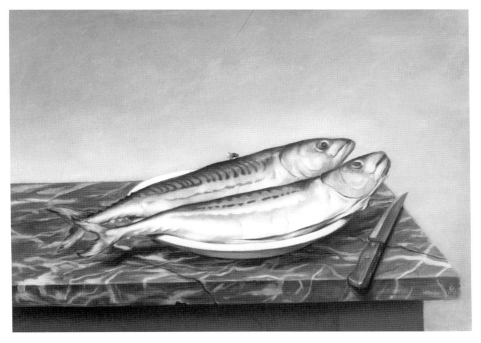

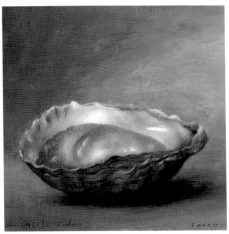

Oyster. Oil on board. 4½ x 4½ in., 1982,
collection Derek Strauss Esq.

OPPOSITE: *Brace of Partridges.* Oil on
panel. 24 x 18 in., 1977, collection
P. W. Fane Esq.

oysters, mullets, and mackerel. Other subjects for his still lifes include gulls eggs,
dead game birds, bottles, glasses of wine and fruit. It is with his superb studies of
blackberries, strawberries, raspberries and cherries that we can see Lincoln's real
mastery of his art. The fruits are skilfully rendered, and the composition, the balance
of light and shade and the surrounding details are acutely observed.

In his earlier still lifes, Lincoln often used tempera but he turned increasingly
to oils which allowed him a more fluent working style. The tempera paintings
were sometimes on Leoncini boards brought back from Florence or on boards
made up by his wife, who also helped to grind the pigments and mix them into
a paste with a drop of white wine. At the same time an emulsion of two raw egg
yolks, one egg white and either some stand oil or varnish was prepared in the
blender, to which was added the pigment paste. The drop of alcohol helped
preserve the raw egg and the mixture could be kept for up to six weeks in sealed
jars. For his oils, Lincoln usually worked on board rather than on canvas, and the
boards were prepared in much the same way as those for tempera paintings.
Marine ply was cut to size, painted with three or four layers of home made gesso
which was sanded before applying a number of coats of oil paint. This oil paint
was of a reddish brown colour, similar to the boule colour used as a ground by
gilders. Once the work was finished, Lincoln would varnish it using an art
restorer's formula rather than a commercially prepared varnish. This was a mixture
of cosmolloid wax and ketone resin which he applied with a spray gun. It gave a
beautiful and very even sheen.

Being a craftsman and perfectionist, Lincoln liked to be involved in the whole
process of creating a picture, from going to the timber merchants, grinding the
colours and ultimately making the frames. He was doubtful about many commercial

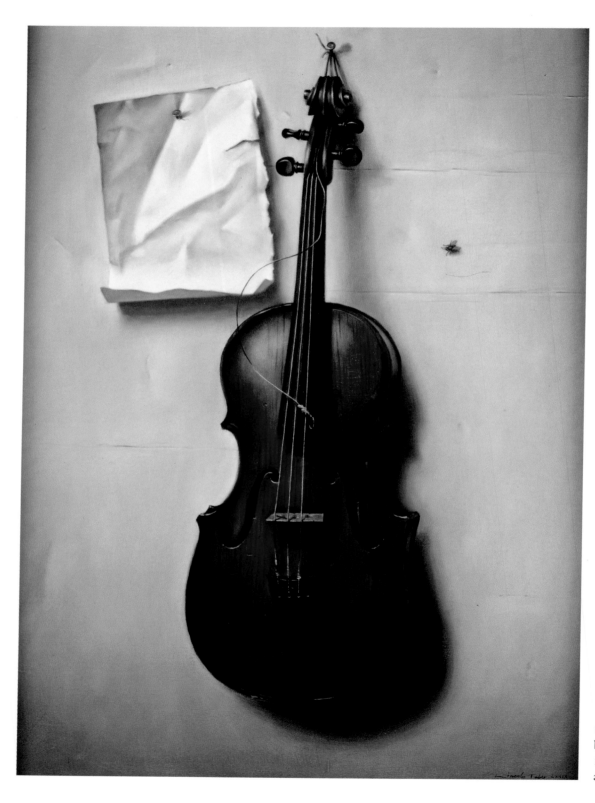

Old Violin. Oil on
board. 24 x 18 in.,
1979, collection Lord
and Lady Tanlaw.

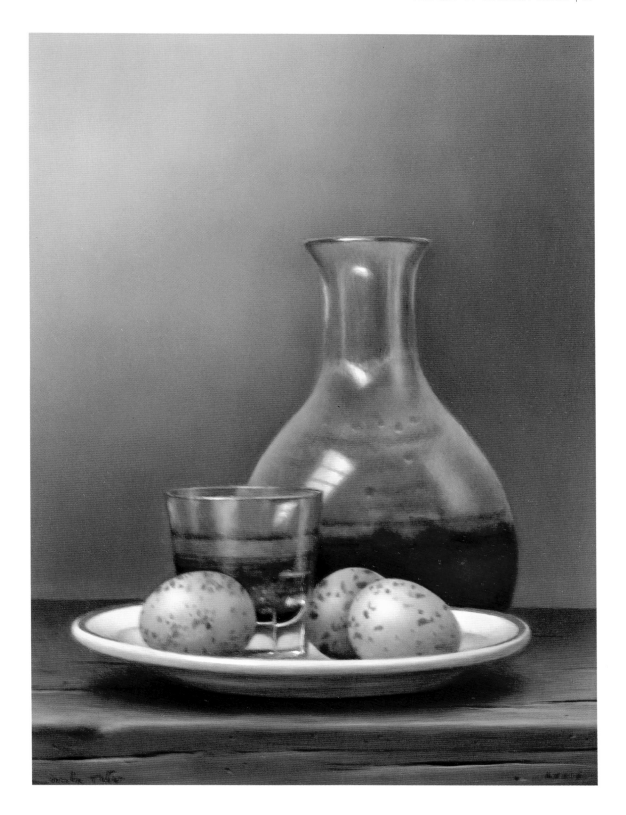

Gulls Eggs and Decanter. Oil on board. 12 x 8 in., 1979, collection S. Teale Esq.

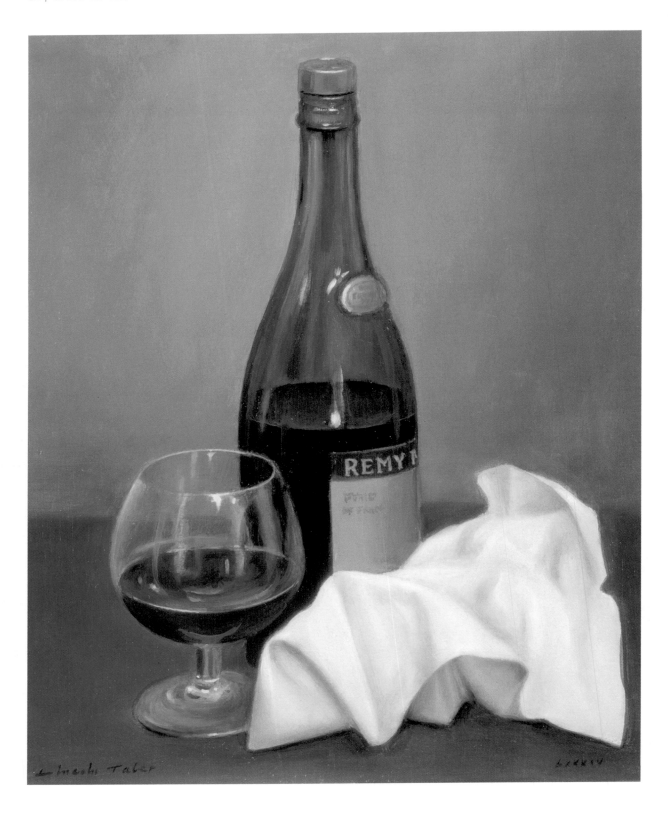

mouldings, so he began making his own while still in Florence. He scoured the antique shops for old frames which he would restore, or buy wide mouldings in plain wood which he and Jacqueline would prepare, gild and paint. In England he found it impossible to buy suitable moulding, so he turned to wainscot moulding, beading and sheets of marine ply which he turned, as if by magic, into 18th century-style frames. Later he discovered the charm of walnut veneer, which he soaked, cut into pieces, glued to the marine ply, polished and finally distressed using an awl to create worm holes. He also liked to apply roundels brought back from Italy in the corners. When working at the Savoy, Lincoln had made friends with the restaurant manager, Antonio Celant who was fascinated by frame making. He began to make Lincoln's frames, and, under his influence, their size and extravagance increased.

OPPOSITE: *Bottle of Brandy.* Oil on board. 12 x 10 in., 1985, collection Mr and Mrs W. Byrnes.

BELOW: *Bottlescape.* Oil on board. 15 x 20 in., 1980, collection Mrs Flavia Ormond.

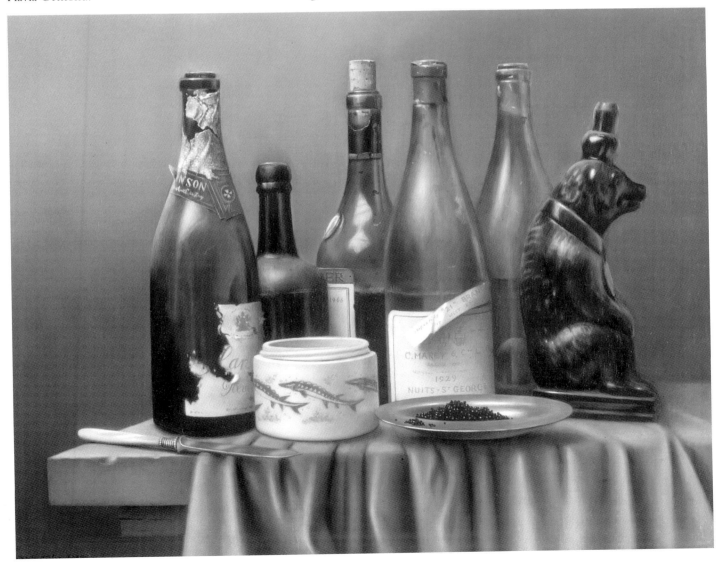

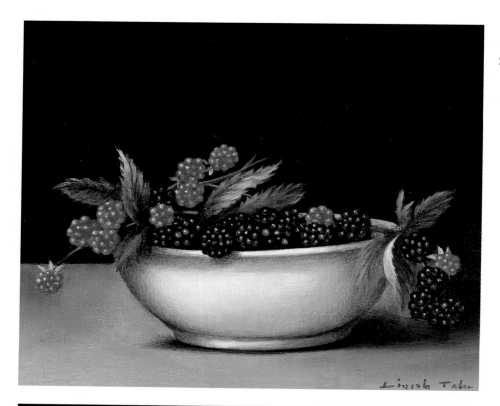

Bowl of Blackberries. Oil on board. 5 x 7 in., 1984, collection Derek Strauss Esq.

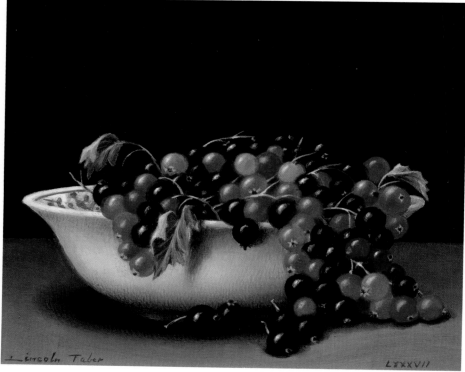

Bowl of Black and Red Currants. Oil on board. 5 x 7 in., 1987, collection P. W. Fane Esq.

Bowl of Gooseberries. Oil on board.
5 x 7 in., 1987, collection P. W. Fane Esq.

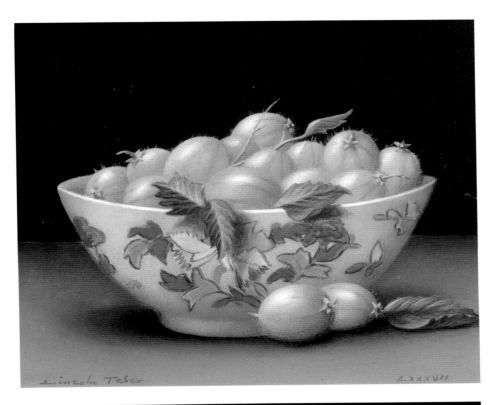

Bowl of Strawberries. Oil on board.
5 x 7 in., 1984, collection P. W. Fane Esq.

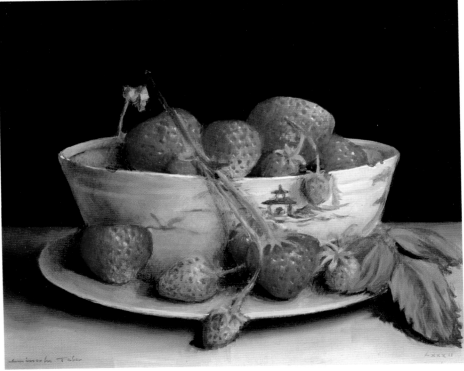

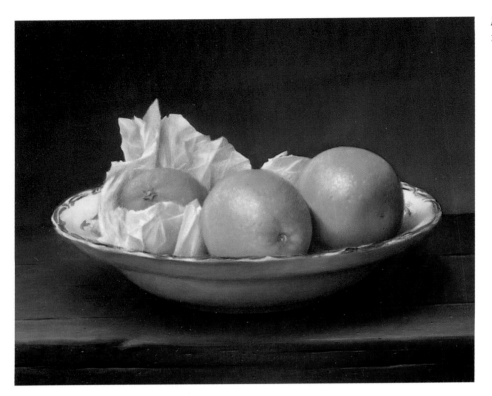

Bowl of Oranges. Oil on board. 8 x 12 in., 1979, collection R. Gare Esq.

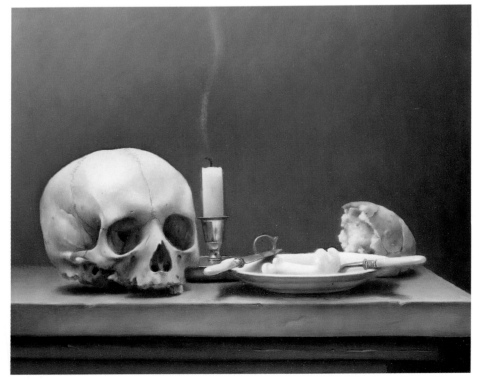

Artists Table. Oil on board. 15 x 18 in., 1979, whereabouts unknown.

THE FINAL YEARS 1985–9

Life in Fingringhoe was happy for Lincoln, his wife and their young son. He loved walking in the countryside as well as along the East Anglian beaches where he would spend hours beach combing, and he also liked boats. A neighbour owned a small day boat which was kept in the Colne Estuary. Lincoln was at his happiest spending the day on this boat exploring the creeks and estuaries, although he regularly fell foul of the notorious Essex tides, and often ran it aground. He enjoyed deep sea fishing in East Anglia and Wales. Another interest was model aeroplanes which he made and flew with a local club. Lincoln was very practical and good with his hands, and even managed to put a new engine into a Fiat 500.

There was little that Lincoln enjoyed more than long evenings spent discussing art, and when in London he would spend his spare time with artists friends such as Richard Foster, Tony Bream, and Julian Barrow as well as patrons who had become close friends such as Peter Fane and Hal Danby. Lincoln enjoyed talking about art and techniques, but he was less interested in the contemporary scene, which deeply depressed him. He admired the work of Dali, Bacon and Freud, but other leading figures such as Picasso and Matisse he disliked. His real interest lay in the Renaissance draughtsmen such as Raphael and Leonardo, but he also admired artists such as Turner, Constable and Beardsley on whose work he would buy books.

In Fingringhoe there were few artists about, but there were still late night parties with friends. One acquaintance was the master forger, Tom Keating, who lived nearby in East Bergholt. Neither Lincoln nor Jacqueline knew that Keating was involved in forging Samuel Palmer drawings and watercolours, but later, when his forging activities had become public, they recalled his great interest in their unique collection of antique paper, bought in Florentine junk shops over a period of many years.

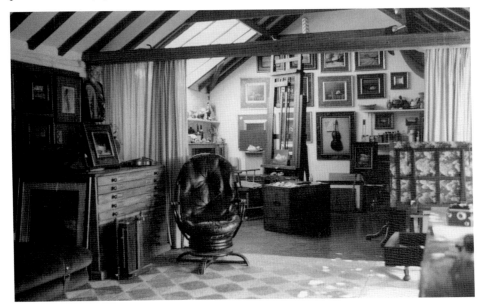

Lincoln's studio in Fingringhoe.

The pressures of work were, however, considerable. Despite good sales and plentiful commissions, money remained a problem because of the irregular way in which it came in, a problem suffered by most artists. In a letter of April 1986 to Peter Fane he wrote:

I'm in dire straights at the moment, especially with my bank – it's the old cash flow problem. Although I've got quite a lot of good prospects coming up, the important thing at the moment is to get the overdraft down soon.

It became increasingly important for Lincoln to have a London studio in order to carry out portrait commissions. For the portrait of Princess Anne, he borrowed Richard Foster's studio in Thurloe Square, and also made use of Julian Barrow's studio in Tite Street. However in 1983 he began to share a studio in Broadhurst Gardens, Swiss Cottage where he spent increasing amounts of time, returning to Fingringhoe at the weekends. The studio had a single bedroom attached, although the kitchen was in the main studio. It was part of an Edwardian house, purpose-built for an artist, having belonged to the painter Eric Agnew whose widow lived downstairs. Niccolo Caracciolo had taken a lease on the studio some ten years earlier, and no longer needing a full-time London base, he passed it on to Lincoln.

In 1985, disaster struck when Lincoln came off a motor bicycle on the island of Mustique. He was in the States for the opening of a small one-man show at the Hotel Twin Dolphin in Cabo San Lucas, Mexico which was owned by his cousin David Haliburton and had a wealthy American clientele. He continued on to Florida to complete the portrait of Peggy Byrnes and then on to Mustique where he was working on a portrait of John Hailwood. He broke his femur in the accident in addition to damaging his teeth, and was flown to hospital in Barbados where he stayed for ten days before being transferred to London where he remained for two months. He had to undergo both physio and hydrotherapy in England and it took a long time for his leg to improve. In a letter of March 25th 1985 he wrote to his mother:

Well, I've been out of hospital now for over two weeks. We've been staying in the studio in London (which is very near the hospital), and I was going back every day for physio and to have my dressings changed. The doctors were very pleased with how quickly I am progressing considering the extent of the injuries. We are now back at Jaggers …and Jacqueline is doing my dressings twice a day… Poor Jacqueline learned from the nurses in the Wellington how to do it, and it's not very pleasant packing a gaping hole in my backside… I am going to see the plastic surgeon on Friday but I don't think he will have to close it up now as it is closing naturally which is what he would prefer – and so do I. I don't want another operation.
I have had a temporary bridge made so I look more or less like a human now… I had quite a lot of bone broken above my teeth and that takes ages to heal completely, and that is amazingly fast considering it was cut almost in half right down the middle. The lip had to have stitches in Barbados and that is alright now.

Snail's Progress. Collage and charcoal. 12 x 9 in., 1985 collection Mrs D. Wolfers.

Although Lincoln made a good recovery from the accident, the episode had seriously damaged his finances as well as his usual *joie de vivre*. He appeared to be suffering from depression in 1986 and 1987 and his output of pictures was greatly reduced. In 1988 he made his last visit to the United States, staying briefly with his mother as well as visiting Mexico and New York.

Lincoln Taber's death remains something of a mystery. In November 1988 he had arranged to spend the weekend in Fingringhoe with Jacqueline and his son and left his studio in Broadhurst Gardens in a black taxi with his portfolio and briefcase. Some hours later he was found on the ground outside the Inn on the Park in Knightsbridge. He had serious head injuries and was taken to Westminster Hospital where they realised he was also suffering from kidney failure. He was transferred to Charing Cross Hospital for a brain scan and then onto the Royal Free where he died on January 13th 1989. An inquest was held into what exactly had happened, and Peter Fane offered a reward for the recovery of his portfolio and briefcase both of which were missing. Travelling from Swiss Cottage to Liverpool Street by taxi would not have taken him via Knightsbridge, and it is possible that he was on his way to a meeting. It is also possible that either he had an argument with the taxi driver and left the cab without his possessions, or that he was mugged. The police insisted that there were no suspicious circumstances arguing that his head injuries were consistent with a fall. The family continued to disagree with the police view of the incident.

Shortly before he died Lincoln confided in some notes written for himself:

> It's nice to be accepted for what I am, and that is a mature juvenile delinquent with a slightly larger than average pea brain, that is taking what is thrown (at him) as it comes. I only long to get my head within view of the surface, let alone above, because what I could achieve without the continual financial drawbacks, I would amaze even myself! Still, I count myself extremely lucky to have arrived as far as I have, and am not complaining – only philosophising.

The funeral was held in St Andrew's Church, Fingringhoe on Monday 23rd January 1989. The family had expected some 30 people to attend, but in the event the church was packed and many of the congregation had to stand. The day had started grey and overcast, but towards midday the haze lifted and a cool East Anglian sun came out. An address was given by his friend and patron Peter Fane:

> We first met in the Spring of 1974, he was to draw in sanguine my wife, and I knew instantly that both he and Jacqueline would have to become one of my family's greatest friends – and so they did. And for those who were tuned into his wavelength they would be quick to discover this rather shy and sometimes diffident man's lovable characteristics.
> He was delightful company, funny, generous, appreciative – he had a wonderful sense of the ridiculous and of course he was blessed with his great talent. His sense of fun enabled us so often to set aside the seriousness of our daily lives and he could soon have us joining in with his boyish pranks. We might be met at Colchester Station by a hideous warty faced masked

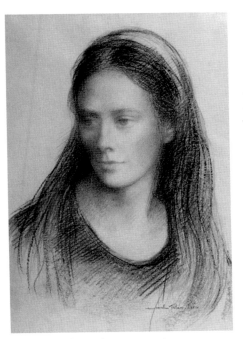

Ruth Fane. Sanguine. 14 x 20 in., 1974.

man, or be greeted, in spite of his physical discomforts, at the Wellington Hospital with a pair of horribly hairy feet sticking out of the end of his bed. And then there was the serious side – his painting... I fell in love, as have so many others, with his paintings – no matter what the subject. The bumble bees, his trompe-l'oeil, the oysters, the bowl of berries – of these William Butler might have said "No doubt God could have made better berries, but doubtless God never did." The peaceful Essex landscape, over there, not far from this Church, the beastly bluebottle alighting upon the dining room wall and not least those lovely portraits which Annigoni said were so beautifully drawn and executed.

All give so much pleasure. My family and I are lucky enough to have many of his pictures, and I know that there is not a day that goes by when I do not pause to admire one or another.

On his day he would plunge himself into his work with care and dedication and the effort that went into finishing his paintings must have, and indeed did, strain him to his extremities, and perhaps many like myself have never really understood the stress he was going through to produce a painting which he so much wanted to be perfect and to please.

It is easy to forget that Linc, who slipped so perfectly into our hearts and lives, was in fact born and raised some 6000 miles away in California. This lovely American in his own eccentric way became one of us: we are fortunate that he will have left behind for us so many happy and long lasting memories together with his legacy of beautiful paintings.

Linc will live on in all our hearts for ever.

There are other tributes to Lincoln Taber which stand as testimonies to his talent. His dealer Nöel Napier-Ford wrote:

Whilst it is probably the case that the early influences in an artist's life stay with him always, and he is bound to be a man of his time, the personality of the individual is surely the vital part, providing the essential originality. The brief span of Lincoln Taber's life leaves many unanswered questions about his art: the evidence of so much talent in the works we know is there for all to see, but to where was he travelling, we can only guess. Like an image in one of his own "Vanitas" the candle of his life was snuffed out too soon.

Self Portrait. Charcoal.
14 x 12 in., 1974, collection
Mr and Mrs T. Conant.

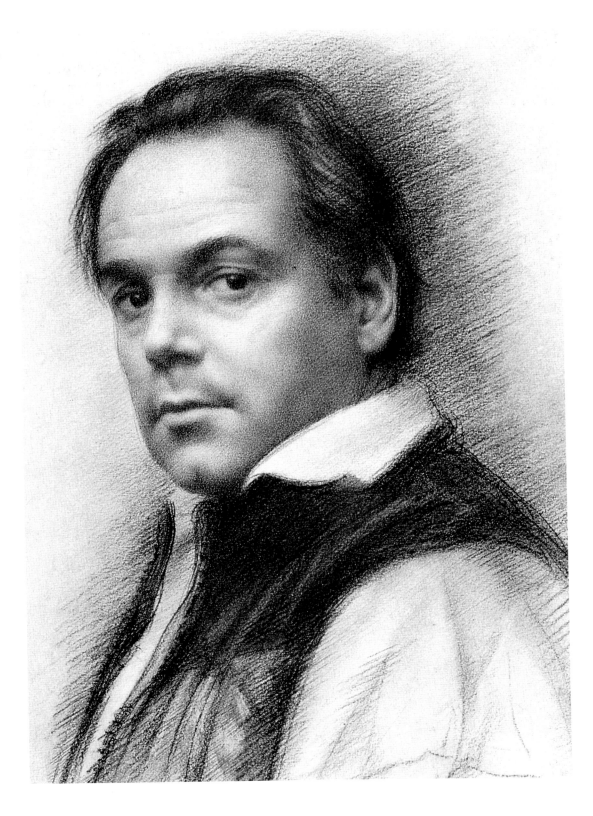

LIST OF EXHIBITIONS

Mixed exhibitions

1966 Galleria III, Florence, Italy.

1966 Piazza S. Spirito, Florence, Italy.

1968 Colchester Arts Society, Minories, Colchester, Essex.

1969 Onwards a regular exhibitor at the Royal Academy Summer Exhibition Royal Society of Portrait Painters and the National Society of Wildlife Artists.

1975 The R.A. Bevan Collection, Minories, Colchester, Essex.

1981 Ivor and Joan Weiss Gallery, Colchester, Essex.

1982 Shared exhibition at Ivor and Joan Weiss Gallery, Kelvedon, Essex.

1983 Contemporary Portraits at the King Street Galleries, St James's, London.

One-Man exhibitions

1975 Ancient House Gallery, Holkham, Norfolk.

1977 King Street Galleries, St James's, London.

1979 King Street Galleries, St James's, London.

1982 Savoy Hotel, Strand, London and King Street Galleries, St James's.

1984 King Street Galleries, St James's, London.

1985 Hotel Twin Dolphin, Cabo San Lucas, Mexico.

Publications

Images of Deception by Celastine D'Ars. Phaidon.

House and Garden Book of Interiors.

House and Garden Painted Rooms.

Paintability by Jocasta Innes. Weidenfeld and Nicholson.

Paint Magic by Jocasta Innes. Windward and Berger Paints.

Summer Portrait by Robert Harling. Chatto and Windus.

Grand Illusions by Caroline Cass. Phaidon.

CATALOGUE RAISONNÉ

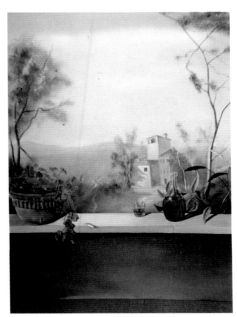

Italianate landscape, 1966.

1964

Florence roof tops from Annigoni's studio. Pencil. 8 x 6 in. Given to J. J. Tufnell Esq., 1974. Purchased by Jacqueline Wolfers.

Portrait of Old Man. Charcoal. 8 x 6 in. Sold 1975 at Ancient House Gallery exhibition.

Reverse of nude torso study done at Signorina Simi's studio. Charcoal. 20 x 13 in. Artist's widow.

Landscape of Flatford Mill. Oil on board. 4 x 6 in. Artist's widow.

Landscape of Isola D'Elba. Oil on board. 4 x 6 in. Artist's widow.

Copy of del Sarto. Sanguine. 18 x 14 in. Given to Mrs Simon Birch, property A. L. Taber III.

1965

Mural at Jaggers, Fingringhoe, Jacqueline sitting on a wall. Tempera on plaster. 9 x 15 ft. Commissioned by Mrs Simon Birch.

Landscape of Fingringhoe Marsh. Oil on board. 6 x 8 in. Purchased by Frances Wynn Eyton

Landscape of Fingringhoe Marsh. Oil on board. 6 x 8 in. Purchased by Frances Wynn Eyton

1966

Italianate landscape. Mural Panel. Tempera on board. 60 x 40 in. Purchased by Suzette Keefer, Los Angeles, California.

Portrait of Guilio Benvenuti. Charcoal. 20 x 14 in. Property A. L. Taber III.

1967

Portrait of Emma Curtis. Head and shoulder. Tempera on board. 24 x 18 in. Commissioned by Mrs N. Hardinge.

Portrait of Philip Curtis. Head and shoulder. Tempera on board. 24 x 18 in. Commissioned by Mrs N. Hardinge.

Beaumont Hall. Mural panel. Tempera on board. 20 x 36 in. Commissioned by Colonel T. Williamson.

Nude Portrait, Full Length of Barbara Gerard. Tempera on board. 60 x 48 in. Commissioned by Mrs B. Gerard.

Landscape, Malibu. Tempera on board. 22 x 15 in. Purchased by Simon Birch Esq.

Leda and the Swan. Sanguine. 8 x 6 in. Commissioned by Simon Birch Esq.

1968

Mural in Dining Room, Brantham Glebe. Tempera on plaster. Commissioned by Simon Birch Esq.

Mural in Guild Hall, Gt Waltham, 3 trompe-l'oeil fireplaces. Tempera on plaster. Commissioned by J. J. Tufnell Esq.

Portrait of Isabelle Hohler. Three quarter. Oil on board. 26 x 20 in. Commissioned by Major T. Hohler.

Langenhoe Rectory. Oil on board. 20 x 30 in. Commissioned by Alan Carrick Smith Esq.

Portrait of Sarah Thistlethwayte. Head and shoulders. Oil on board. 26 x 22 in. Commissioned by P. Thistlethwayte Esq.

Portrait of Andy, head. Sanguine. 20 x 14 in. Commissioned by J. J. Tufnell Esq.

Mural in Guild Hall, Gt Waltham, of book shelves. Two panels. Tempera on plaster. Commissioned by J. J. Tufnell Esq.

Portrait of Julian Birch. Sanguine. 20 x 14 in. Commissioned by Mrs S. Birch.

Portrait of James Birch. Sanguine. 18 x 14 in. Commissioned by Mrs S. Birch.

1969

Portrait of Sarah Micklam. Head and shoulders. Oil on board. 28 x 22 in. Commissioned by D. Micklam Esq.

Sanguine study of above portrait for J. J. Tufnell Esq. 20 x 14 in.

Mural in Orangery at Langley's, Gt Waltham. Tempera on plaster. 72 x 60 in. Commissioned by J. J. Tufnell Esq.

Two mural panels of Saints, Guild Hall, Gt Waltham. Tempera on plaster. Commissioned by J. J. Tufnell Esq.

Portrait of Edward Hunt. Head. Sanguine. 20 x 14 in. Commissioned by John Hunt Esq.

Study for Langley's mural. Oil on board. 17 x 12 in. Purchased by Simon Birch Esq.

Portrait of Christopher Curtis. Head. Sanguine. 20 x 14 in. Commissioned by Christopher Curtis Esq.

Painted Door of the Book of Hours. Eight panels. Tempera on wood. Commissioned by J. J. Tufnell Esq.

Drawing for J. J. Tufnell. (unidentified)

Colby Lodge, Pembrokeshire. Oil on board. 24 x 30 in. Commissioned by I. O. Chance Esq.

Four charcoal and sanguine studies for above picture. Artist's widow

Portrait of Mrs S. Williams in High Sheriff's regalia. Head and shoulders. Egg tempera on board. 26 x 20 in. Commissioned by Mrs S. Williams.

Copy of Botticelli's portrait of a young man holding a medal. Oil on board. 7 x 6 in. Commissioned by J. J. Tufnell, purchased in 1991 by Simon Birch from a sale at Christies and now in the collection of the artist's son.

Two doors decorated in the Pompeian style. Tempera on wood. Commissioned by J. J. Tufnell Esq.

1970

Portrait of Anne Fane. Head and shoulders. Sanguine. 20 x 14 in. Commissioned by Peter Fane Esq.

Portrait of Duncan Thom's Mother. Head and shoulders. Sanguine. 20 x 14 in. Commissioned by D. Thom, now in Beaumont, Canada.

Portrait of Joan Hunt. Head. Sanguine 20 x 14 in. Commissioned by John Hunt Esq.

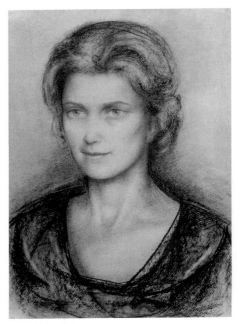

Sarah Micklam, 1969.

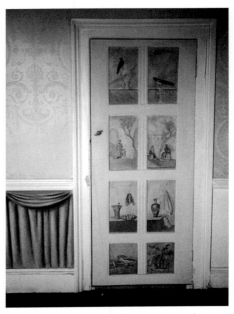

Door decorated in the Pompeian style, 1969.

Still life with Bread. Oil on board. 8 x 10 in. Purchased by Dr Corringham.

Painting of marble busts. Tempera. Commissioned by J. J. Tufnell Esq.

Mural of trompe-d'oeil curtains in Guild Hall, Gt Waltham. Tempera on plaster. Commissioned by J. J. Tufnell Esq.

Landscape with snow. Oil on board. 8 x 10 in. Purchased by Frances Wynne Eyton.

Reclining nude of Jacqueline. Charcoal. 20 x 30 in. Purchased by Robert Bevan Esq. Used in 1979 by Robert Harling Editor of *House and Garden* for book jacket for his book *A Summer Portrait.*

Completes mural in dining room at Brantham Glebe for Simon Birch Esq.

Fireplace at Leeze Priory, 1971.

1971

Portrait of Richard Freemantle. Head and shoulders. Oil on board. 30 x 20 in. Commissioned by R. Freemantle Esq.

Portrait of Fiona Macquiston. Head and shoulders. Sanguine. 20 x 14 in. Commissioned by S. Macquiston Esq.

Cartoon for tapestry. Oil on canvas. 60 x 70 in. Commissioned by J. Whitaker for Mrs M. Martineau.

Portrait of Max Ward. Head and shoulders. Sanguine. 12 x 10 in. Commissioned by Major B. Ward. First picture accepted at the Royal Society of Portrait Painters 1972.

Portrait of Major-General W. Olding. Head and shoulders. Sanguine. 20 x 14 in. Commissioned by Major-General W. Olding.

Copy of Elizabethan Lady. Oil on board. 24 x 20 in. Commissioned by J. J. Tufnell. Purchased by Simon Birch from Christie's Sale 1992.

Murals of shelves and a fireplace at Leeze Priory. Tempera on plaster. Commissioned by Mrs Norman Butler.

Copy of portrait of Mrs Currie. Oil on board. 10 x 12 in. Commissioned by J. J. Tufnell. Purchased 1990 by P. W. Fane Esq.

Portrait of Emma Dixon. Head. Sanguine. 20 x 14 in. Commissioned by Alan Carrick Smith Esq.

Portrait of Bruce Dixon. Head. Sanguine. 20 x 14 in. Commissioned by Alan Carrick Smith Esq.

Two Dutch still lives. Oil on copper. 4 x 6 in. Commissioned by J. J. Tufnell Esq.

Portrait after Boucher. Sanguine. 10 x 8 in. Commissioned by J. J. Tufnell Esq.

Portrait of Elena Linklater. Head and shoulders. Sanguine. 20 x 14 in. Commissioned by Dr J. Linklater.

Pompeian murals in bathroom at Salmons, Fingringhoe. Tempera on plaster. Commissioned by Christopher Kerrison Esq.

Emma Dixon, 1971.

1972

Drawing of a Stag Beetle. Charcoal. 10 x 8 in. Commissioned by Simon Birch Esq.

Portrait of Mops Millard Barnes. Head. Sanguine. 20 x 14 in. Commissioned by John Millard Barnes Esq.

Portrait of David Boyd. Head. Sanguine. 20 x 14 in. Commissioned by
Dr B. Maclean.

Copy of Cleopatra. Pencil. 12 x 10 in. Commissioned by J. J. Tufnell Esq.

Copy of Lelong still life. Oil on board. 4 x 6 in. Commissioned by J. J. Tufnell Esq.

Landscape with pots in foreground. Tempera on canvas. 40 x 44 in. Purchased by
Elaine Dunn, now in California.

Landscape of Fingringhoe. Oil on board. 10 x 14 in. Purchased by G. Benvenuti
of Florence.

Still life Beledevere copy. Oil on board. Commissioned by J. J. Tufnell Esq.

Study of a Parrot. Pencil. 10 x 7 in. Purchaser unknown.

Study of a Parrot. Pencil. 10 x 7 in. Purchaser unknown.

Copy of still life with flowers. Oil on board. 14 x 10 in. Commissioned by
J. J. Tufnell. Purchased by Simon Birch in Christie's sale 1991 and now in
artist's sons collection.

Study for portrait of Miss Winifred Sharpe. Sanguine and pastel. 30 x 28 in.
Property of artist's widow.

Landscape of Fingringhoe. Oil on board. Given to Mrs Clara Taber.

Murals at South House. Venetian Bedroom. Tempera on plaster. Commissioned by
J. J. Tufnell Esq.

Three Shields for Brantham Church. Tempera and gilt. 21 x 13 in. Diocese of
St Edmundsbury.

Landscape at Fingringhoe. Oil on board. 6 x 10 in. Purchased by Mrs
N. Beresford-Jones.

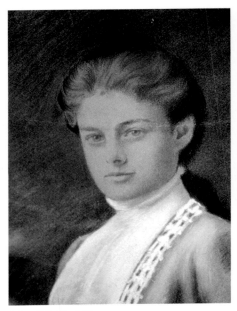

Miss Winifred Sharpe, 1972.

1973

Mural in dining room in 55 Sloane Street. Tempera on plaster. Commissioned by
Mrs Stuart Paton.

Cupboard door trompe-d'oeil of book shelves. Tempera on wood. Commissioned by
Mrs Stuart Paton.

Copy of portrait of Duke de Medici. Oil on board. 22 x 18 in. Commissioned
by J. J. Tufnell. Purchased by Simon Birch at Christie's sale 1991 and now in
artist's son's collection.

Murals in South House, Gt Waltham. Tempera on plaster. Commissioned by
J. J. Tufnell Esq.

Portrait of the Duchess of Hamilton. Head and shoulders. Oil on board. 28 x 18 in.
Commissioned by the Duke of Hamilton.

Study in sanguine and charcoal for above portrait. 20 x 14 in. for the Duke of
Hamilton.

Murals at South House. Tempera on plaster. Commissioned by J. J. Tufnell Esq.

Copy of still life. Oil on board. Commissioned by J. J. Tufnell Esq.

Repainting head on Romney portrait. Oil on canvas for J. J. Tufnell Esq.

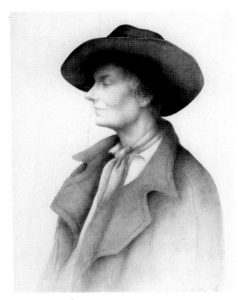

Bettine Birch, 1974.

1974

Drawing of a fly. Charcoal. 6 x 5 in. Won in a bet by Roy Hammond over the result of Oxford and Cambridge boat race.

Portrait of Miss Winifred Sharpe. Three quarter length. Tempera on board. 38 x 28 in. Commissioned by Colonel George Judd.

Portrait of Bettine Birch. Head and shoulders. Charcoal. 15 x 10 in. Commissioned by Simon Birch Esq.

Nude back view of Jacqueline. Sanguine and charcoal. 18 x 28 in. Purchased by Bettine Birch, now in artist's son's collection.

Portrait of Mr French. Head and shoulder. Sanguine. 20 x 14 in. Commissioned by J. J. Tufnell Esq.

Still life basket of bread. Oil on board. 10 x 14 in. Purchased by Dr B. Maclean.

Still life of orange and decanter. Tempera on board. 20 x 14 in. Purchased by Peter Fane Esq.

Landscape at Boxted. Oil on board. 6 x 8 in. Purchased by Julian Birch Esq.

Landscape at Thorrington Mill. Oil on board. 6 x 9 in. Purchased by Mr and Mrs N. Beresford Jones.

Mural at South House in drawing room. Tempera on plaster. Commissioned by J. J. Tufnell Esq.

Portrait of Ruth Fane. Head and shoulders. Sanguine. 20 x 14 in. Commissioned by P. W. Fane Esq.

Portrait of Peter William Fane. Head and shoulders. Sanguine. 20 x 14 in. Commissioned by P. W. Fane Esq.

Adam and Eve Door. Oil on wood. 58 x 22 in. Commissioned by Major-General Odling.

Still life with cat. Oil on board. 5 x 8 in. Commissioned by Simon Birch Esq.

1975

Bumblebee from the top. Oil on board. 3 x 3 in. Commissioned by P. W. Fane Esq.

Bumblebee from the side. Oil on board. 3 x 3 in. Commissioned by P. W. Fane Esq.

Dragonfly. Oil on board. 4 x 3 in. Commissioned by Lady Anne Tennant.

Bumblebee. Oil on board. 3 x 3 in. Commissioned by the Duchess of Hamilton.

Strawberry. Oil on board. 3 x 3 in. Commissioned by the Duchess of Hamilton

Bumblebee. Oil on board. 3 x 3 in. Purchased by I. O. Brandt Esq.

Fishwife. Reverse Canvas. Oil on board. 20 x 18 in. Exhibited RA Summer Exhibition. Purchased by H. Solomons. Used as book jacket for Celastine D'Ars book *The Images of Deception*, published by Phaidon. In 1992 in a sale at Bonhams, purchased by Scott Maidmentand, now in Australia.

Still life with bottle of Chianti. Oil on board. 20 x 14 in. Purchased by Dr B. Maclean.

Posthumous portrait of the 14th Duke of Hamilton. Three quarter. Charcoal. 48 x 50 in. Commissioned by the Duke of Hamilton.

Mural in gazebo at Colby Lodge, Pembrokeshire. Tempera on plaster. Commissioned by I. O. Chance Esq.

Still Life with bottle of Chianti, 1975.

Portrait of Sue Danby. Head and shoulder. Sanguine. 20 x 14 in. Commissioned by Hal Danby Esq.

ONE-MAN EXHIBITION, THE ANCIENT HOUSE GALLERY, HOLKHAM.

Landscape, South Green Fingringhoe. Oil on board. 6 x 9 in. Purchased by P. W. Fane Esq.

Landscape, Hay Lane, Fingringhoe. Oil on board. 6 x 9 in. Purchased by Mrs C. Williams.

Landscape, Colne Estuary. Oil on board. 9 x 14 in. Purchased by Frances Wynne Eyton.

Landscape over Amroth S. Wales. Oil on board. 8 x 10 in. Purchased by Levant and given to the Reverend and Mrs Mark Wells.

Landscape, Castletownshend, Co Cork. Oil on board. 8 x 12 in. Purchased by Clare Wilkins.

Landscape at Layer Marney, Essex. Oil on board. 7 x 9 in. Purchased by Elizabeth, Countess of Leicester.

Still life, bread and wine. Oil on board. 10 x 12 in. Purchased by Robin Leslie Esq.

Still life of gulls eggs. Oil on board. 6 x 8 in. Purchased by Robin Leslie Esq.

Still life of dead pigeons. Oil on board. 27½ x 25 in. Sold to Clare Wilkins, later purchased by Simon Birch in a charity auction.

Bumblebee. Oil on board. 4 x 3 in. Purchased by Frances Wynne Eyton.

Bumblebee. Oil on board. 3 x 3 in. Purchased by Elizabeth, Countess of Leicester.

Portrait of Jane Middleton. Head and shoulders. This was commissioned by Patricia Middleton but turned down. Sold to unknown purchaser.

Mackerel. Oil on board. 10 x 14 in. Purchased by Mr and Mrs N. Beresford-Jones.

Self-portrait. Head and shoulders. Pencil. This was exhibited at the RPP in 1972. Purchaser unknown.

Self-portrait. Head and shoulders. Pencil. Purchased by Natalie Bevan.

Parrot. Pencil. Purchased by Lady Carey Basset.

Parrot. Pencil. Purchased by John Hunt Esq.

Stagbeetle. Oil on board. 5 x 4 in. Purchased by John Hildreth Esq.

Portrait of Emma. Sanguine. 20 x 14 in. Property of Mrs A. Hardinge.

1976
Bumblebee. Oil on board. 3 x 3 in. Purchased by Frederic Lees Esq.

Bumblebee. Oil on board. 3 x 3 in. Given to Mrs Clara Taber.

Bread and wine. Oil on board. Size and purchaser unknown.

Pyefleet oysters. Oil on board. 8 x 10 in. Purchased by V. G. Fuller at the RA Summer Show.

Wasp with pearl pin. Oil on board. 3 x 3 in. Purchased by Frederic Lees Esq.

Self-portrait. Sanguine. Purchased by Somerset de Chair. Sold at Christie's sale at St Osyth's Priory and purchased by Simon Birch in 1984.

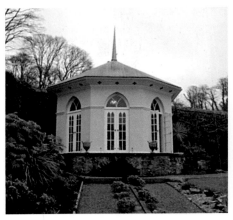

Gazebo, Colby Lodge, 1975.

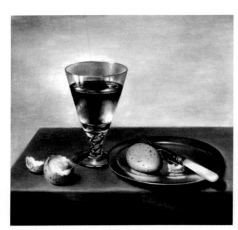

Still life of gulls eggs and wine, 1975.

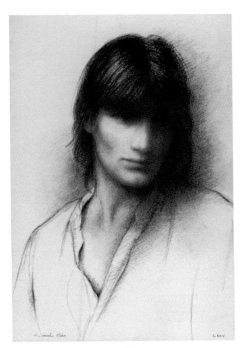

Portrait of James Birch, 1976.

Tree in Winter, 1977.

Portrait of Katy Thistlethwayte. Head and shoulders. Charcoal. 20 x 14 in. Commissioned by Mr & Mrs Peter Thistlethwayte.

Stag Beetle. Pencil. 6 x 4 in. Purchased by Robin Leslie Esq.

Mural ceiling in gazebo with signs of the zodiac at Colby Lodge in Pembrokeshire. Tempera on plaster. Commissioned by I. O. Chance Esq.

Portrait of Pippa Sydney. Head and shoulder. Sanguine. 20 x 14 in. Commissioned by Deryk Sidney Esq.

Bumblebee. Oil on board. 3 x 3 in. Purchased by Mr and Mrs N. Beresford-Jones.

Bumblebee. Oil on board. 3 x 3 in. Purchased by Mrs Anne Fane.

Bumblebee. Oil on board. 3 x 3 in. Commissioned by J. J. Tufnell Esq.

Landscape of South Green, Fingringhoe. 12 x 9 in. Purchased by Mrs S. Williams.

Portrait of James Birch. Head. Sanguine. 20 x 14 in. Commissioned by Bettine Birch.

Bouts Copy. Oil on board. Commissioned by J. J. Tufnell Esq.

Bumblebee. Oil on board. 3 x 3 in. Purchaser unknown.

Mural Pots in drawing room. South House. Tempera on plaster. Commissioned by J. J. Tufnell Esq.

Mural Library. Gardens at Langleys South House. Tempera on plaster. Commissioned by J. J. Tufnell Esq.

Landscape of Amroth. Oil on canvas. 30 x 36 in. Purchased by P. W. Fane Esq.

Mural in Bedroom. Venetian scenes, South House. Tempera on plaster. Commissioned by J. J. Tufnell Esq.

Bumblebee. Oil on board. 3 x 3 in. Purchaser unknown.

Wasp. Oil on board. 3 x 3 in. Purchaser unknown.

Plate of Oysters. Purchaser and size unknown.

1977
ONE-MAN EXHIBITION, THE KING STREET GALLERY, ST JAMES'S, LONDON.

Hercules Beetle. Oil on board. 6 x 4 in. Purchaser unknown.

Jacqueline. Charcoal. 17 x 11 in. Purchased by Lord Tanlaw.

Cherries. Oil on board. Purchaser and size unknown.

Landscape of Pembrokeshire. Oil on board. Purchaser and size unknown.

Nude. Oil on board. Purchaser and size unknown.

Bumblebee. Oil on board. 3 x 3 in. Stone Gallery, Newcastle.

Portrait of Ruth Fane. Head and shoulders. Oil on board. 30 x 26 in. Commissioned by P. W. Fane Esq.

Brace of Partridges. Oil on board. 25 x 20 in. Purchased by P. W. Fane Esq.

Portrait of the Duke of Hamilton. Head. Sanguine. 20 x 14 in. Commissioned by the Duchess of Hamilton.

Stagbeetle. Oil on board. 5 x 3½ in. Purchased by Marshall Spink Esq.

Bumblebee. Oil on board. 3 x 3 in. Mrs J. M. Scott.

Stagbeetle. Oil on board. 5 x 3½ in. Purchased by the Duke of Hamilton.

Wasp. Oil on board. 3 x 3 in. Purchased by the Duke of Hamilton.

Bumblebee. Oil on board. 3 x 3 in. Desmond Hayward Esq.

Portrait of Hilly. Head. Sanguine. 20 x 14 in. Commissioned by Hilly van Steeden.

Portrait of Alina Stonor. Head and shoulder. Sanguine. 20 x 14 in. Commissioned by Lord Camoys.

Portrait of Flavia Watts Russell. Head and shoulders. Sanguine. 20 x 14 in. Commissioned by Anthony Watts Russell Esq.

Tree in winter. Pencil. 9 x 7½ in. Purchased by Col G. Judd.

Nude study. Pencil. 21 x 13 in. Purchaser unknown.

Oysters and glass. Oil on board. 7½ x 10 in. Purchased by Lord Tanlaw.

Bottle and dove. Oil on board. 15½ x 13½ in. R.W. Reeves Esq.

Bumblebee. Oil on board. 3 x 3 in. Purchased by Colonel G. Judd.

Gulls eggs. Oil on board. 6½ x 8½ in. Purchased by Somerset de Chair Esq.

Plate of oysters. Oil on board. 9 x 11 in. Purchased by Lord Tanlaw.

Pigeons. Oil on board. 24 x 18 in. Purchased by John Cobbold Esq.

North Berwick, East Lothian. Oil on board. 7 x 10½ in. Purchased by F. Lowrey Corry Esq.

Stagbeetle. Oil on board. 5½ x 7½ in. Peter Comberti Esq.

Still life of oysters. Oil on board. Purchased by Lord Tanlaw.

Roman River, Fingringhoe. Oil on board. 7½ x 10½ in. Purchased by H. Melville Esq.

Jay. Oil on board. 24 x 18 in. Purchased by Wyndham Green Esq.

Pomegranates and bread. Oil on board. 8½ x 11½ in. Purchased by Lord Tanlaw.

Italian loaf. Oil on board. 12 x 16 in. Purchased by R. Hammond Esq.

South Green, Fingringhoe. Oil on board. 7½ x 10½ in. Lord Tanlaw.

Flatford, Suffolk. Sepia. 8 x 12 in. Purchaser John Hunt Esq.

Langharne, Wales. Oil on board. 7 x 10 in. Purchaser David Yorke Esq.

Marshes, Fingringhoe. Oil on board. 12 x 16 in. Purchased by Frances Wynne Eaton.

Old canvas. Oil on board. 30 x 25 in. Purchased by A. Stanley Clarke Esq.

Wasp. Oil on board. 3½ x 3½ in. Desmond Hayward Esq.

Tiger Beetle. Oil on board. 3 x 3 in. Desmond Hayward Esq.

Snipe and decanter. Oil on board. 16 x 12 in. R.W. Reeves Esq.

Porcelain cup. Oil on board. 6½ x 8½ in. Purchased by June Leslie.

South Green, Fingringhoe. Oil on board. 8 x 12 in. Mrs A.E. Bodie.

Beluga caviar. Oil on board. 17½ x 13 in. Purchased by John Hunt Esq.

Plate of herrings. Oil on board. 8 x 11½ in. Purchased by A. Stanley Clarke Esq.

Bread and white wine. Oil on board. 3 x 4½ in. Purchased by R. Hammond Esq.

Wasp with pearl pin. Oil on board. 3 x 4½ in. Desmond Hayward Esq.

Self portrait. Pencil. 22 x 15 in. Purchased by A. Stanley Clarke Esq.

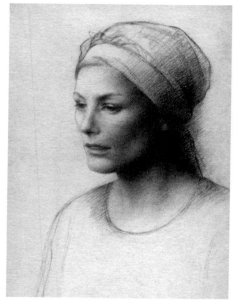

Hilly, 1977.

Old Canvas, 1977.

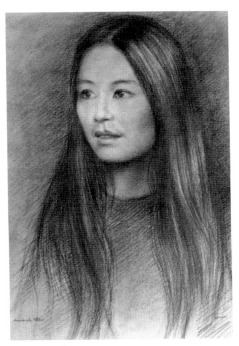

Lady Tanlaw, 1977.

Portrait of Emma. Sanguine. 19½ x 14½ in. Purchased by Anne Hardinge.

Bumblebee. Oil on board. 5 x 5 in. Commissioned by David Yorke Esq. for James Yorke.

Portrait of Lucinda Douglas Menzies. Sanguine. 14 x 20 in. Commissioned by Catherine Whitworth Jones.

Portrait of Arabella Douglas Menzies. Sanguine. 20 x 14 in. Commissioned by Catherine Whitworth Jones.

The Collector. Oil on board. 30 x 25 in. Exhibited at RA Summer Exhibition. Purchased by Lord Tanlaw.

Portrait of Michael Grimwade. Sanguine. 20 x 14 in. Commissioned by Michael Grimwade Esq.

Study for skull. Charcoal. 5 x 6½ in. Purchased by Michael Grimwade Esq.

Portrait of Lady Tanlaw. Sanguine. 20 x 14 in. Commissioned by Lord Tanlaw.

Stagbeetle. Oil on board. 4 x 7 in. Purchased by Stone Gallery, Newcastle.

Gadfly. Oil on board. 3 x 3 in. Purchased by the Duke of Hamilton.

Death's head hawk-moth. Oil on board. 8 x 8 in. Purchaser unknown.

Bumblebee. Oil on board. 3 x 3 in. Purchased by J.B. Pangrian Esq. of Canada.

1978

Portrait of M. Redier. Head and shoulders. Oil on board. 25 x 20 in. Commissioned by Carter, Wilkes, and Fane and given by them to M. Redier. Now in France.

Portrait of Veronica Bowring. Sanguine. 20 x 14 in. Commissioned by Mrs Bowring.

Stagbeetle No 1. Oil on board. 4 x 6 in. RA Summer Exhibition. Purchased by A. Adler Esq.

Bumblebee. Oil on board. 3 x 3 in. Purchaser unknown.

Bumblebee. Oil on board. 3 x 3 in. Purchased by Two Rivers Petroleum.

Flowers on mural at South House. Tempera on plaster. Commissioned by J. J. Tufnell Esq.

Portrait of Rosie Tinney. Head and shoulders. Sanguine. 20 x 14 in. Commissioned by John Tinney Esq.

Portrait of Anne Chapell. Head and shoulders. Sanguine. 20 x 14 in. Commissioned by P. Chapell Esq.

Stagbeetle. Oil on board. 4 x 6 in. Commissioned by Lord Tanlaw.

Bumblebee. Oil on board. 3 x 3 in. Commissioned by Lord Tanlaw.

Stagbeetle. Oil on board. 4 x 6 in. Purchased by Dr Propert.

Bumblebee. Oil on board. 3 x 3 in. Commissioned by A. Watts Russell Esq.

Mural at Poons Restaurant, King Street, Covent Garden. Tempera on plaster. Commissioned by Lord Tanlaw.

Posthumous portrait of John Weller Poley. Head and shoulders. Oil on board. 25 x 20 in. Commissioned by Mrs Nancy Weller Poley.

Bumblebee. Oil on board. 3 x 3 in. Commissioned by Mrs Nancy Weller Poley.

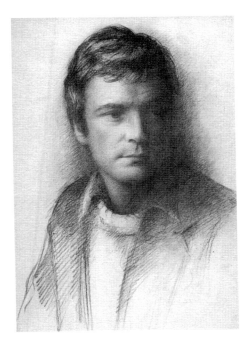

Michael Grimwade, 1977.

Copy of a Guardi. Oil on canvas. 11 x 17 in. Commissioned by J. J. Tufnell Esq.

Stagbeetle. Oil on board. 4 x 6 in. Commissioned by the Duke of Hamilton.

Mural of Suffolk landscape with still life, Capel Hall, Trimley, Suffolk. Tempera on plaster. Commissioned by John Cobbold Esq.

Posthumous portrait of John Middleton. Sanguine. 20 x 14 in. Commissioned by Mrs P. Middleton.

Hercules Beetle. Oil on board. 4 x 6 in. Commissioned by the Duke of Hamilton.

Death's head hawk-moth. Oil on board. 8 x 8 in. Commissioned by the Duke of Hamilton.

Portrait Teresa de Chair. Head and shoulders. Sanguine. 30 x 20 in. Commissioned by Somerset de Chair Esq.

Portrait of John Cobbold wearing Ipswich Town sweater. Half length. Oil on board. 25 x 20 in. Commissioned by J.Cobbold Esq.

Landscape. Oil on canvas. 20 x 11 in. Purchased by J. Cobbold Esq.

Mural Alcove of false cupboard. Tempera on plaster. Commissioned by J. Cobbold Esq.

Lady Juliet and Helena de Chair. Half length. Sanguine. 25 x 18 in. Commissioned by Somerset de Chair Esq.

Still life of bottles. Oil on board. 17 x 22 in. Commissioned by I. O. Chance Esq.

Stagbeetle. Oil on board. 4 x 6 in. Purchased by Two Rivers Petroleum.

Gadfly. Oil on board. 3 x 3 in. Purchased by Two Rivers Petroleum.

Wasp. Oil on board. 3 x 3 in. Purchased by Two Rivers Petroleum.

Bumblebee. Oil on board. 3 x 3 in. Commissioned by Elizabeth, Countess of Leicester.

Bumblebee. Oil on board. 3 x 3 in. Commissioned by Elizabeth, Countess of Leicester.

Wasp. Oil on board. 3 x 3 in. Commissioned by A. Watts Russell Esq.

Wasp. Oil on board. 3 x 3 in. Commissioned by the Duke of Hamilton.

Portrait of Mrs Borradale. Half length. Sanguine. 20 x 14 in. Commissioned by Mrs J. Sunnucks.

1979
SECOND ONE-MAN EXHIBITION AT KING STREET GALLERY, ST JAMES'S.

Old violin. Oil on board. 24 x 18 in. Purchased by Lord Tanlaw.

River Stour. Oil on canvas. 14 x 10 in. Purchased by Mark Dawson Esq.

Pembrokeshire Hills. Oil on canvas. 36 x 40 in. Purchased by P. W. Fane Esq.

Beach Amroth. Oil on canvas. 5½ x 8 in. Purchased by I.O. Chance Esq.

South Green. Oil on canvas. 15 x 18 in. Purchased by Lord Tanlaw.

Jug and orange. Oil on board. 13 x 10 in. Purchased by Lord Tanlaw.

Pannino and glass of Chianti. Oil on board. 8½ x 10 in. Purchased by C. F. Williams Esq.

South Green. Oil on canvas. 9 x 12 in. Purchased by Lord Tanlaw.

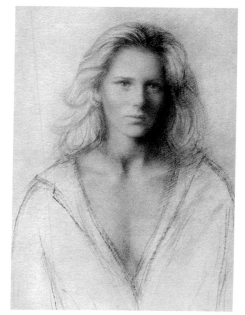

Teresa de Chair, 1978.

Reversed canvas, 1979.

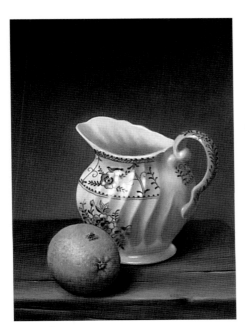

Jug and orange, 1979.

Grey Mullet, 1979.

Reversed canvas. Oil on canvas. 14 x 12 in. Purchased by Lord Tanlaw.

Primrose Hill. Oil on canvas. 6 x 8 in. Purchased by Mr and Mrs L. Bull.

Nude study. Pencil. 9 x 15 in. Purchased by Lord Tanlaw.

Marshes, Fingringhoe. Oil on canvas. 28 x 36 in. Purchased by Vahid Azabib Esq.

Artist's table. Oil on board. 15 x 18 in. Purchased by Tillotson Commodities.

Jacqueline. Sanguine. 17 x 12½ in. Purchased by Mr Sadaghani.

Wine glass and bread. Oil on board. 11 x 13 in. Purchased by Paul Gilliat Esq.

Oyster. Oil on board. 4½ x 6½ in. Purchased by Simon Birch and donated to the Fishmongers Company.

Thames. Oil on canvas. 8 x 16 in. Purchased by the Savoy Hotel.

Hornet. Oil on board. 3 x 3 in. Purchased by R. Hammond Esq.

Gulls eggs and decanter. Oil on board. 14½ x 12 in. Purchased by John Cobbold Esq.

Jacqueline. Sanguine. 25 x 19 in. Purchased by A Stanley Clarke Esq.

Thames from the Savoy (2). 7 x 10 in. Purchased by Giles Shepard Esq. for the Savoy Hotel. One painting was used for the Savoy's Christmas Card.

Grapes and Jug. Oil on board. 14 x 16 in. Purchased by Anne Fane.

Jacqueline at the window. Pencil. 11 x 8 in. Purchased by John de Vere Hunt Esq.

Bowl of oranges. Oil on board. 9½ x 11½ in. Purchased by Frank Chapman Esq., now owned by Bob Gare Esq.

Hornet. Oil on board. 3 x 3 in. Purchased by R. Hammond Esq.

Hercules Beetle. Oil on board. 4 x 6 in. Purchased by A. Stanley Clarke Esq.

Bowl of cherries. Oil on board. 8 x 8 in. Purchased by P. Gilliat.

Stagbeetle. Oil on board. 8 x 12 in. Purchased by Diana Hammond.

Pembrokeshire Hills. Oil on board. 8 x 12 in. Purchased by Jeremy Phillips Esq.

Snipe. Oil on board. 12 x 10 in. Purchased by Frank Chapman Esq.

Nude study of Miranda. Sanguine. 18 x 13 in. Purchased by Frank Chapman Esq.

Bumblebee. Oil on board. 3 x 3 in. Purchased by Toby Gore Esq.

Portrait of Biden Ashbrooke. Head and shoulders. Sanguine. 20 x 14 in. Commissioned by Veronica Ashbrooke.

Copy of ancestral portrait. Oil on canvas. 30 x 20 in. Nicholas Delamaine Esq.

Vanitas. Oil on canvas. 25 x 30 in. Commissioned by Toby Gore Esq.

Violin. Oil on board. 24 x 18 in. Commissioned by Peter Comberti Esq.

Portrait of Sara Plunket. Head and shoulders. 20 x 14 in. Exhibited RPP 1980. Commissioned by Luca Cumani Esq.

Lady Alport. Half length. Oil on board. 30 x 20 in. Commissioned by Lord Alport.

Grey mullet. Oil on board. 15 x 18 in. Purchased by Hal Danby Esq.

Gulls eggs and glass of wine. Oil on board. 11 x 12 in. Purchased by Jeremy Phillips Esq.

Oyster. Oil on board. 5 x 6 in. Purchased by Mrs Legatt.

South Green. Oil on board. 8 x 12 in. Purchased by Mrs M.A. Robinson.

1980

Portrait of Sophie Schellenberg. Head. Sanguine. 20 x 14 in. Commissioned by Mrs Jan Jupe.

Murals in Thames Foyer at the Savoy Hotel. Tempera on plaster board.

Self Portrait. Half length. Oil on board. Exhibited at the Royal Society of Portrait Painters. 1980. Purchased after the artist's death by Simon Birch from the artist's widow. 1990. Property of A. L. Taber III

Portrait of Paula Ruane. Head. Sanguine. 20 x 14 in. Commissioned by Kevin Ruane Esq.

Portrait Heri Quancard. Head. Sanguine. 20 x 14 in. Commissioned by Mons. Henri Quancard, and now in Bordeaux.

Bumblebee. Oil on board. 3 x 3 in. Purchased by Giles Shepard Esq.

Portrait of Fleur Riddle. Head. Sanguine. 20 x 14 in. Commissioned by Peter Riddle Esq.

Portrait of Ricca Weller Poley. Head. Sanguine. 20 x 14 in. Commissioned by Nancy Weller Poley.

Portrait of Veronica Ashbrooke. Head. Sanguine. 20 x 14 in. Commissioned by Veronica Ashbrooke.

Portrait of Phylda Pilley. Head. Sanguine. 20 x 14 in. Commissioned by John Pilley Esq.

Portrait of Phylda Pilley. Head. Sanguine. 20 x 14 in. Property of artist's widow.

Portrait of Toby Weller Poley. Head. Sanguine. 20 x 14 in. Commissioned by Mrs Nancy Weller Poley.

Portrait of Brise Quancard. Half length. Oil on board. 30 x 20 in. Commissioned by Mons. Henri Quancard.

Portrait of Nicholas Quancard. Half length. Oil on board. 30 x 20 in. Commissioned by M. Henri Quancard.

Portrait of Laurence Quancard. Half length. Oil on board. 30 x 20 in. Commissioned by M. Henri Quancard. All these pictures are in Bordeaux, France.

Portrait of Charity Birch. Sanguine (unfinished). 20 x 14 in. Commissioned by Julian Birch Esq.

1981

Portrait of Sir Seymour Egerton. Head and shoulder. Oil on board. 30 x 20 in. Commissioned by Church House and presented to him for services rendered.

Portrait of Tim Steele. Head. Sanguine. 20 x 14 in. Commissioned by Anthony Steele Esq.

Portrait of Louise Steele. Head. Sanguine. 20 x 14 in. Commissioned by Anthony Steele Esq.

Portrait of Clare Steele . Head. Sanguine. 20 x 14 in. Commissioned by Anthony Steele Esq. to give to his wife on their 25th wedding anniversary.

Skull. Pencil. 6 x 8 in. Donated for charity auction, and won by Michael Foster Esq.

Paula Ruane, 1980.

Henri Quancard, 1980.

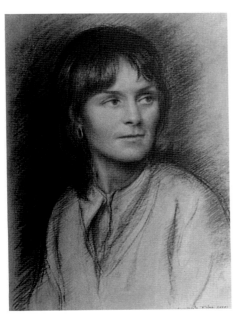

Portrait of Nicola Strauss, 1981.

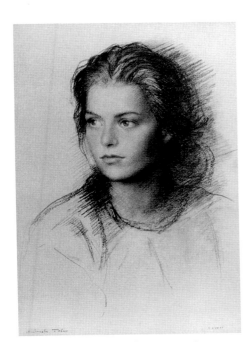

Portrait of Henrietta Garnett, 1982.

Asparagus. Oil on canvas. 11 x 12½ in. Sold through Ivor Weiss in a mixed exhibition at his gallery on Colchester. Purchaser unknown.

Bumblebee. Oil on board. 3 x 3 in. Sold through Ivor Weiss in a mixed exhibition. Purchaser unknown.

Regents Park. Oil on board. 6 x 8 in. Property of the artist's widow.

Primrose Hill. Oil on canvas. 12 x 16 in. Property of the artist's widow.

Standing nude. Pencil. 25 x 16 in. Property of artist's widow.

Cocktail shaker and lemon. Oil on board. 12 x 8 in. Purchaser unknown.

Bowl of Cherries. Oil on board. 10 x 12 in. Purchased by J. Phillips Esq.

Murals in gamekeeper's hut. Gt Waltham. Tempera on plaster board. Commissioned by J. J. Tufnell Esq.

Portrait of Anne Pearson. Head. Sanguine. 20 x 14 in. Commissioned by Paul Pearson Esq.

Portrait of Carol Dawson. Head. Sanguine. 20 x 14 in. Commissioned by Mark Dawson Esq.

Nude of Carol. Half length. Sanguine. 25 x 18 in. Property of artists's widow.

Pheasants in Gamekeeper's Hut, Gt Waltham. Tempera on plaster board. Commissioned by J. J. Tufnell Esq.

Portrait of Nicola Strauss. Head. Sanguine. 20 x 14 in. Commissioned by Derek Strauss Esq.

Mackerel on a plate. Oil on board. 9 x 11 in. Purchased by Peter Donnelly Esq.

1982

Portrait of Adam Budworth. Head. Sanguine. 20 x 14 in. Commissioned by Mrs Julia Budworth.

Portrait of Henrietta Garnett. Head. Sanguine. 20 x 14 in. Commissioned by Mrs Patricia Garnett.

Portrait of Charles Garnett. Head. Sanguine. 20 x 14 in. Commissioned by Mrs Patricia Garnett.

ONE-MAN EXHIBITION AT THE SAVOY HOTEL.

Blackberries. Oil on board. 5 x 7 in. Purchased by Peter English Esq.

Landscape, Colne Estuary. Oil on canvas. 12½ x 15½ in. Purchased by O. Pointing Esq.

Skull. Oil on board. 9¼ x 11½ in. Exhibited RA Summer Exhibition. Purchased by O. Pointing Esq.

Bowl of cherries. Oil on board. 8 x 9 in. Purchased by Mrs C. Williams.

Self Portrait. Pencil. 13 x 10 in. Purchased by T. Conant Esq.

Dead swan. Tempera on board. 48 x 30 in. Purchased by T. Conant Esq.

Bowl of strawberries. Oil on board. 8 x 9 in. Purchased by P. C. Michael Esq.

Plate of mussels. Oil on board. 7½ x 10½ in. Purchased by P. C. Michael Esq.

Rabbit and partridge. Oil on board. 10 x 12 in. Purchased by J. H. Phillips Esq.

Fly. Pencil. 2 x 2 in. Purchased by R. Hammond Esq.

Laxton Superb. Oil on board. 8 x 10 in. Purchased by Roy Hammond Esq.

Bumblebee. Oil on board. 3 x 3 in. Purchased by T. Emery Esq.

Jacqueline nude. Pencil. 21½ x 30 in. Purchased by Lord Tanlaw.

Jacqueline nude. Sanguine. 21½ x 30 in. Sold by the artist's widow in 1991 at the Simi Show at the David Kerr Gallery.

Pembrokeshire landscape. Oil on canvas. 15½ x 18 in. Purchased by Alastair Black Esq.

Pyefleet oyster. Oil on board. 4½ x 4½ in. Purchased by D. Strauss Esq.

Plovers' eggs. Oil on board. 4½ x 4½ in. Purchased by John Hunt Esq.

Apples. Oil on board. 7½ x 15 in. Purchased by Anne Carr.

Winter, Fingringhoe. Oil on board. 6 x 18 in. Sold 1992 to Mrs S. Cohen.

Winter, Fingringhoe. Oil on board. 6 x 18 in. Sold 1992 to Mrs S. Cohen.

Jacqueline. Oil on board. 9 x 9 in. Property of artist's widow.

Suffolk Landscape. Study for Savoy murals. Oil on canvas. 25 x 50 in. Purchased by the Savoy Hotel.

Artist's lunch. Oil on board. 8 x 9 in. Property of artist's widow.

Loaf of bread. Oil on board. 11 x 13 in. Property of artist's widow.

Miranda. Oil on board. 21 x 16 in. Purchased by A. Tomma Esq.

Tara, nude. Sanguine. 26 x 18 in. Purchased by C. Pertwee Esq.

Tara. Head. Sanguine. 18 x 14 in. Purchased by Jonathan Coe of Harley Art Brokers, 1989, who became the artist's agent from 1985.

Pollo alla Diavolo. Oil on board. 8 x 10 in. Purchased by Hal Danby Esq.

Old Pump House, Polcenigo. Oil on board. 7 x 12 in. Property of artist's widow.

River scene, Polcenigo. Oil on board. 7 x 12 in. Property of artist's widow.

Winter Rose. Oil on board. 12 x 7 in. Property of artist's son.

Regents Park. Oil on board. 12 x 10 in. Property of artist's widow.

Corn field, Polcenigo. Oil on board. 4 x 12 in. Property of artist's widow.

Girl's back. Oil on board. 10 x 7 in. Property of artist's widow.

Old houses, Polcenigo. Oil on board. 10 x 7 in. Property of artist's widow.

Elms. Oil on board. 10 x 7 in. Property of artist's widow.

Mallard. Tempera on canvas on board. 16 x 12 in. Property of artist's widow.

Melanistic and Chinese Pheasants. Tempera on board. 30 x 40 in. Property of artist's widow.

Portrait of Mrs P.C. Michael. Head. Sanguine. 20 x 14 in. Commissioned by Mr P. Michael Esq.

Portrait of HRH Princess Anne. Three-quarter length. 40 x 30 in. Commissioned by the Fishmonger's Company.

Study of head for above portrait. Sanguine. 20 x 14 in. Donated by the artist to Captain Mark Phillips.

Study for Savoy murals (Triptych). Oil on board. 7 x 15 in. Property of artist's widow.

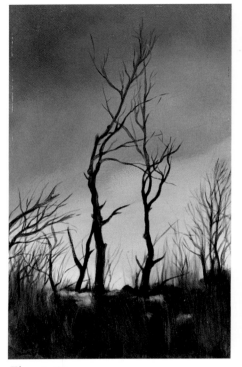

Elms, 1982.

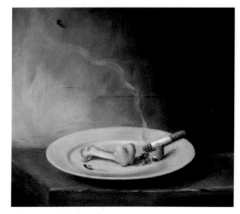

Poor artist's lunch, 1982.

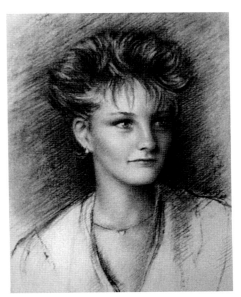

Dominique Fell-Clark, 1982.

Study of head for above portrait (HRH Princess Anne). Sanguine. 20 x 14 in. Purchased by A. Tomma Esq.

Study of head for above portrait (HRH Princess Anne). Sanguine. 20 x 14 in. Property of artist's widow.

Portrait of Sarah Ward. Head. Sanguine. 20 x 14 in. Commissioned by Max Ward Esq.

SHARED EXHIBITION AT WEISS GALLERY IN KELVEDON.

Portrait of Patricia Pearson. Head. Sanguine. 20 x 14 in. Commissioned by the Hon Mrs P. Pearson.

Reclining Nude. Oil on board. 16 x 28 in. Purchased by Antonio Celant and now in Italy.

Portrait of the artist's son. Oil on canvas. 12 x 10 in. Property of artist's widow.

Field in Fingringhoe. Oil on canvas. 10 x 12 in. Purchased by A. Celant Esq.

Reclining Nude. Sanguine. Size unknown. Purchased by A. Celant Esq.

Regents Park. Oil on board. Size unknown. Purchased by A. Celant Esq.

Wasp, bumblebee and hornet. Triptytch. Oil on board. Each measuring 3 x 3 in. Purchased by A. Celant Esq.

Portrait of Dominique Fell-Clark. Head. Sanguine. 20 x 14 in. Commissioned by John Fell-Clark Esq.

Poor artist's palette. Oil on board. 28 x 30 in. Purchased by Hal Danby Esq.

Blackberries. Oil on board. 5 x 7 in. Purchased by D. Strauss Esq.

Gulls eggs and port. Oil on board. Purchased by A. M. Shelmendine Esq.

1983

Portrait of Mary Pearson. Head. Sanguine. 20 x 14 in. Commissioned by I. O. Chance Esq.

CONTEMPORARY PORTRAITS, KING STREET GALLERY, ST JAMES'S.

Copy of David's Napoleon I. Oil on board. 9 x 5 in. Commissioned by J. J. Tufnell. Purchased by Simon Birch from Christie's auction 1991.

Fly. Oil on board. 3 x 3 in. Purchased by Finn Wang and now in Norway.

Stagbeetle. Oil on board. 4 x 6 in. Puchased by Finn Wang Esq.

Field in Fingringhoe. Oil on board. 9 x 13 in. Purchased by Finn Wang Esq.

Bowl of strawberries. Oil on board. 6 x 8 in. Commissioned by Peter English Esq.

Small study for Savoy murals. Oil on board. Purchaser and size unknown.

Portrait of Noel Durlacher. Head. Sanguine. 20 x 14 in. Commissioned by R. Durlacher Esq.

Portrait of Natasha Durlacher. Head. Sanguine. 20 x 14 in. Commissioned by R. Durlacher Esq.

Portrait of Samantha Durlacher. Head. Sanguine. 20 x 14 in. Commissioned by R. Durlacher Esq.

Portrait of Kitty Schmidt. Head. Sanguine. 20 x 14 in. Commissioned by F. Schmidt Esq.

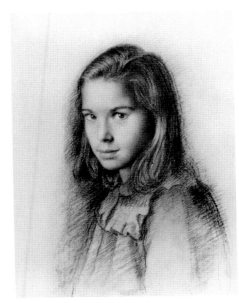

Samantha Durlacher, 1983.

1984

Mural in Beaufort Rooms, Savoy Hotel. Tempera on plaster board.

Portrait of Richard Norman. Head and shoulders. Oil on board. 14 x 10 in. Commissioned by R. Norman Esq.

Portrait of Christine Norman. Head and shoulders. Oil on board. 14 x 10 in. Commissioned by R. Norman Esq.

Stagbeetle. Oil on board. 4 x 6 in. Purchased by F. Schmidt Esq.

Portrait of Maximilian Fane. Sanguine. 20 x 14 in. Given to Mr and Mrs P. W. Fane.

Portrait of Simon Taylor. Head and shoulders. Charcoal. 25 x 20 in. Commissioned by Alison Taylor.

Snail. Oil on board. 3 x 3 in. Purchased by Mrs Giles Shepard.

Portrait of Amanda Dietsch. Head and shoulders. Sanguine. 20 x 14 in. Commissioned by Sally Young.

Portrait of Lucy Clive. Head. Sanguine. 20 x 14 in. Commissioned by David Clive Esq.

Portrait of Victoria Clive. Head. Sanguine. 20 x 14 in. Commissioned by David Clive Esq.

Portrait of Sir Richard Brooke. Head and shoulders. Oil on board. 27 x 20 in. Commissioned by Sir Richard Brooke.

Copy of the King of Rome. Oil on board. 8 x 6 in. Commissioned by J. J. Tufnell Esq.

Portrait of Davina Conant. Head. Sanguine. 20 x 14 in. Commissioned by Tim Conant Esq.

Portrait of Tim Conant. Head and shoulders. Pencil. 28 x 20 in. Commissioned by Tim Conant Esq.

EXHIBITION AT KING STREET GALLERIES.

MADE AN HONORARY MEMBER OF THE AMERICAN PORTRAIT SOCIETY.

Bumblebee. Oil on board. 3 x 3 in. Commissioned by Connie Sutton.

Portrait of Judy Monkland. Head. Sanguine. 20 x 14 in. Commissioned by Michael Monkland Esq.

Quince and bottle. Oil on board. 12 x 8 in. Purchased by M. Monkland Esq.

Bowl of strawberries. Oil on board. 6 x 8 in. Purchased by R. L. C. Eley Esq.

Green umbrella. Oil on board. 40 x 30 in. Purchased by Oliver Eley Esq.

Asparagus. Oil on board. 12 x 18 in. Purchased by Lt.-Col. Peter Gibbs Esq.

Bowl of cherries. Oil on board. 6 x 9 in. Purchased by Derek Strauss Esq.

Tiger Beetle. Oil on board. 4 x 6 in. Purchased by Mrs Ruth Fane.

Snail. Oil on board. 3 x 3 in. Purchased by Peter Lee Esq.

Green bottle. Oil on board. Size unknown. Purchased by P. C. Michael Esq.

Quince. Oil on board. 10 x 8 in. Purchased by David Nathan and now in New Zealand.

Cherries on white paper. Oil on canvas. 10 x 12 in. Purchased by R. Mullens and now in Dallas Texas.

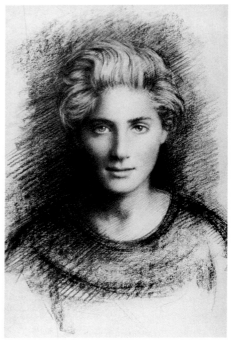

Portrait of Amanda Dietsch, 1984.

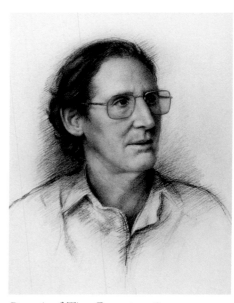

Portrait of Tim Conant, 1984.

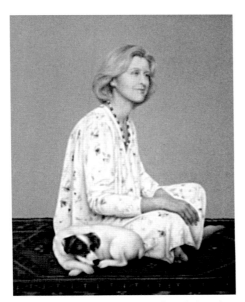

Portrait of Diana Hammond with her dog Sophie, 1985.

Bumblebee. Oil on board. 3 x 3 in. Purchase by Mrs R. Hodges.

Church in Veneto. Oil on board. 6 x 8 in. Purchased by R. Mullens.

Bowl of apples. Oil on board. 10 x 14 in. Purchased by Frank Thornton Esq.

Iceberg roses. Oil on board. 16 x 12 in. Purchased by R. Mullens Esq.

Bag of cherries. Oil on canvas. 10 x 12 in. Purchased by P. C. Michael Esq.

Bumblebee. Oil on board. 3 x 3 in. Purchased by Mrs D. Clive.

Bowl of cherries. Oil on board. 10 x 12 in. Purchased by J. J. Tufnell Esq.

Snail. Oil on board. 3 x 3 in. Purchased by I. Smyth Esq.

Quince and bumblebee. Oil on board. 10 x 8 in. Purchased by Michael Monkland Esq.

Bumblebee. Oil on board. 3 x 3 in. Purchased by Mrs W. Durlacher.

Marshes, Fingringhoe. Oil on board. 12 x 14 in. Purchased by Mrs M. Meakes and given to Mr Moss.

Dali. Pen and Ink. 12 x 14 in. Commissioned by F. Schmidt Esq.

Portrait of Annabelle Fell-Clark. Head. Sanguine. 20 x 14 in. Commissioned by John Fell-Clark Esq.

Death's head hawk-moth. Oil on board. 22 x 26 in. Property of artist's widow.

Candle and books. Oil on board. 8 x 6 in. Sold to Linda Lines.

East Anglian Landscape. Oil on board. 10 x 14 in. Purchased by Lord Camoys.

Quince and bumblebee. Oil on canvas. 10 x 8 in. Purchased by Mrs Omfray.

1985

Portrait of Lindsay Forte. Head. Sanguine. 14 x 20 in. Commissioned by William Byrnes of Florida.

Portrait of James Guinness. Head and shoulders. Oil on board. 30 x 26 in. Commissioned by Mrs Pauline Guinness.

Portrait of Dodo Peat. Half-length. Oil on board. 30 x 26 in. Commissioned by Sir Gerrard Peat.

Portrait of Lucy Sanderson. Head. Sanguine. 20 x 14 in. Commissioned by Mrs John Sanderson.

Birch trees. Oil on board. 6 x 8 in. Purchased by David Halliburton of California.

Strawberries. Oil on board. 6 x 8 in. Purchased by William Byrnes of Florida.

Brandy bottle. Oil on board. 16 x 14 in. Purchased by William Byrnes Esq.

Portrait of Peggy Byrnes. Tempera on board. 20 x 16 in. Commissioned by William Byrnes Esq.

Bumblebee. Oil on board. 3 x 3 in. Purchased by Suzette Keefer of California.

Portrait of Diana Hammond with her dog Sophie. Full length. Tempera on board. 50 x 40 in. Commissioned by Roy Hammond Esq.

Hercules Beetle. Oil on board. 4 x 6 in. Purchased by F. Schmidt Esq.

Portrait of Sophie Ashbrooke. Head and shoulders. Sanguine. 20 x 14 in. Commissioned by Mrs B. Ashbrooke.

Portrait of Aubron Ashbrooke. Head. Sanguine. 20 x 14 in. Commissioned by Mrs B. Ashbrooke.

Portrait of Sophie Ashbrooke, 1985.

Portrait of Desmond Hayward. Head. Sanguine. 20 x 14 in. Commissioned by Desmond Hayward Esq.

Portrait of Fiona Hayward. Head. Sanguine. 20 x 14 in. Commissioned by Desmond Hayward Esq.

Marshes, Fingringhoe. Oil on board. 10 x 12 in. Purchased by Mr and Mrs Paul Bathurst-Norman.

Murals in P. W. Fane's dining room. Tempera on plaster.

Butterfly. Oil on board. 3 x 3 in. Purchased by Mrs W. Durlacher.

1986

Portrait of Mary Breakall. Head. Sanguine. 20 x 14 in. Commissioned by Paul Breakall.

Portrait of David Neeshaw. Head. Sanguine. 20 x 14 in. Commissioned by Mary Breakall.

Portrait of Mark Fitzpatrick. Head. Sanguine. 20 x 14 in. Commissioned by Mary Breakall.

Bowl of strawberries. Oil on board. 9 x 10 in. Commissioned by Wendy Durlacher.

Portrait of Barbara Comfort. Head and shoulder. Sanguine. 30 x 20 in. Commissioned by David Halliburton and now in California.

Still life of fruit in green bowl. Oil on board. 30 x 36 in. Purchased by Vahid Azerbib.

Venetian riverscape. Oil on board. 6 x 10 in. Purchased by Michael Monkland Esq.

Portrait of Thomas Cole. Head. Sanguine. 20 x 14 in. Commissioned by Thomas Cole. Esq

David Neeshaw, 1986.

1987

Murals in hotel bar at the Dedham Vale Hotel. Tempera on plaster. Commissioned by Gerald Milsom Esq.

Asparagus. Oil on board. 12 x 16 in. Exhibited at the RA Summer Show. Purchased by Michael Ross Esq.

Raspberries in green dish. Oil on board. 10 x 12 in. Purchased by Alan Harris Esq.

Strawberries in blue china bowl. Oil on board. 8 x 10 in. Purchased by Alan Harris Esq.

Bumblebee. Oil on board. 3 x 3 in. Purchased by Mrs Flavia Watts-Russell.

Portrait of Lucy Brooke. Head. Sanguine. 20 x 18 in. Commissioned by David Brooke Esq.

Portrait of Emily Pritchard Gordon. Head. Sanguine. 20 x 14 in. Commissioned by Giles Pritchard-Gordon Esq.

Gooseberries. Oil on board. 6 x 10 in. Commissioned by P. W. Fane Esq.

Black and red currants. Oil on board. 6 x 10 in. Commissioned by P. W. Fane Esq.

1988

Mural in White Hall Court. Tempera on plaster. Commissioned by Linda Lines.

Portrait of John Hailwood. Half-length. Oil on board. 30 x 20 in. Commissioned by John Hailwood Esq.

Alice Pritchard-Gordon, 1988.

Portrait of Evan Gibbs. Head. Sanguine. 20 x 14 in. Commissioned by Lt.-Col. Peter Gibbs Esq.

Portrait of Francesca Kendall. Head. Sanguine. 20 x 14 in. Commissioned by Mr and Mrs Conant.

Portrait of Alice Pritchard-Gordon. Head. Sanguine. 20 x 14 in. Commissioned by Giles Pritchard-Gordon Esq.

Portrait of Linda Lines. Three-quarter length. Oil on board. 40 x 30 in. Commissioned by Linda Lines.

Portrait of Caroline Pilley with her dogs. Oil on board. 30 x 36 in. Commissioned by John Pilley Esq.

Portrait of Anthony Stanley Clarke. Head and shoulders. Sanguine. 25 x 18 in. Commissioned by Betty Stanley Clarke.

Still life of strawberries. Oil on board. 8 x 10 in. Purchased by Giles Pritchard-Gordon Esq.

Still life of gulls eggs. Oil on board. 12 x 16 in. Purchased by Giles Pritchard-Gordon Esq.

Bumblebee. Oil on board. 3 x 3 in. Purchased by Mrs Frank Thornton.

Bumblebee. Oil on board. 3 x 3 in. Purchased by Flavia Watts-Russell.

Cabbage white. Oil on board. 4 x 3 in. Purchased by P. W. Fane Esq.

Lincoln Taber died on 13th January 1989.

All sizes are approximate. Measurements in inches. Height before width. The pictures in the above list are ones that were commissioned or purchased by Lincoln Taber's clients.

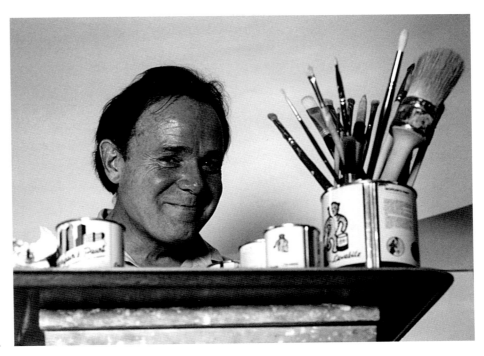

Lincoln working at Whitehall Court, 1988.

LIST OF SUBSCRIBERS

Michael and Alice Abril

Mrs V. Ashbrooke

Will and Salai Barclay

Miranda Barran, widow of Tristram Lincoln's friend

Julian Barrow

Paul and Sue Bathurst Norman

Andrew N.W. Beeson

Nicholas and Nell Beresford-Jones

Ann and Henry Bett

Terry and Penny Bird

P. Andrew Borges

Mrs Paul Breakell

Sir Richard Brooke Bt

Julia Budworth

Lord Camoys

Shirley D'Ardia Caracciolo

Billy and Sally Carbutt

Colonel and Mrs Jeremy Carter

Miranda Chapman and Michael Lambert

Francis D. S. Chapman

Mr and Mrs George Chapman

Gerald Charrington

Sir Tobias Clarke Bt

David Clive

Jonathan Coe

Mr and Mrs Hugh Coghill

Valeria, Viscountess Coke

Robert and Muriel Cole

Thomas Coles

Tim and Davina Conant

Mrs Luca Cumani

M. P. Dawson

Simon C. Dickinson Ltd

Emma Dixon

Patrick Drysdale

Giovanna Ducci

Mariana and Alistair Duncan

Mrs Richard Durlacher

The Countess of Erroll

Essex Record Office

Mr and Mrs Peter W. Fane

The Fishmongers Company

Richard Foster

Nancy Fouts

Janet Fulford

R. J. Gare

Barbara Gerard

James E. A. R. Guinness, C.B.E.

J. A. F. Hailwood, C.B.E.

Richard Harvey

John and Lydia Haward

Desmond Heyward

F. Hoare

David Leo Holcomb

John Taber Holcomb

Ronald Eugene Holcomb

Zola Ruth Taber Holcomb

Sir Michael and Lady Holt

Philip Hope-Cobbold

Ken Howard

Mrs Victoria Keeble

Tom Kirkwood

Mr and Mrs Peter Lee

Mrs J. R. Leslie

Lloyd Hayden

F. H. Lowry-Corry

Barbara S. Maclean

Heather McConville

Sonia and Graham Meredith

Richard Meredith

Sir Peter and Lady Michael

Alfred Mignano

Mr and Mrs Michael Monkland

Noël and Christine Napier-Ford

W. H. Patterson

Mrs M. J. Paul

Mrs J. M. Peake

Dr David C. Pearson

Dodo Peat and Amanda Ferragamo

John M. Pelly

Christopher Pertwee

S. L. Phipps, Susan Crawford

Michael de Piquet-Wicks

Giles and Lou Pritchard-Gordon

Elizabeth Purdy

Carole (Missy) Robiglio

Mr F. Schmidt

Giles R. C. Shepard C.B.E.

Lynette Singers

P. Smedley

Daphne Stevens (ex-student of Nerina Simi 1977-79)

Mr and Mrs George Storey

Mr D. R. Strauss

J. H. F. H. Sutcliffe

The Lady Juliet Tadgell

Lady Tanlaw

Mr and Mrs Frank Thornton

Annamaria Toma

Mr and Mrs Michael Turney

Vost's Fine Art Auctioneers and Valuers

Lady Victoria Waymouth

John Whitaker

Nelson Holbrook White

Mrs H. Whitworth Jones

Clare Wilkins

Mrs Gerald Wombwell

Charles Yorke

Mrs David Yorke

James Yorke

LINCOLN TABER

MCMXLI MCMLXXXIX